PERTH

THE POSTCARD COLLECTION

JACK GILLON

AMBERLEY

First published 2021

Amberley Publishing
The Hill, Stroud, Gloucestershire, GL5 4EP
www.amberley-books.com

Copyright © Jack Gillon, 2021

The right of Jack Gillon to be identified as the
Author of this work has been asserted in accordance
with the Copyrights, Designs and Patents Act 1988.

ISBN 978 1 3981 0225 5 (print)
ISBN 978 1 3981 0226 2 (ebook)

British Library Cataloguing in Publication Data.
A catalogue record for this book is available from the
British Library.

Origination by Amberley Publishing.
Printed in Great Britain.

CONTENTS

INTRODUCTION

One would have thought that there was no Perth man (out of the asylum) who would not have rejoiced in his unstained tranquillity, in the delightful heights that enclose him – in his silvery Tay – in the quiet beauty of his green and level Inches.

(Lord Cockburn, *Journals*, 1874)

There is some debate about the origin of the name Perth. It is said to derive either from a Pictish word for wood or copse or from '*Aber-tha*', meaning the 'mouth of the Tay'. For centuries Perth was known as St John's Toun, from its association with its church dedicated to John the Baptist.

The location of Perth, at the lowest crossing point of the Tay, was fundamental to its development and it has been inhabited since prehistoric times. Its location close to Scone, with its royal connections, was an important factor in the growth of the town. It was the capital of Scotland until the mid-fifteenth century and an important religious centre.

Perth was given royal burgh status in the early twelfth century under King David I and developed as one of the most affluent towns in Scotland. The navigable River Tay was a significant factor in the prosperity of the town, as ships could sail up the river and the harbour carried out an extensive foreign trade. Perth also had a thriving industrial base in leather, linen and metalwork.

Perth, however, suffered its fair share of troubles from invading armies, outbreaks of the plague and destructive floods.

In the nineteenth century, whisky production, insurance and dyeing were additions to Perth's traditional industries and burgeoning economy. The first railway station in Perth opened in 1848, further enabling expansion, and the city became known as the 'Gateway to the Highlands'.

An outward sign of this growing prosperity were the 'improvement schemes of considerable magnitude which were adopted and carried out' – new grid-plan developments of elegant Georgian terraces to the north and south sides of the town were built and the old medieval layout was rationalised.

Perth has been known for centuries as the 'Fair City'. However, in the late 1990s the government decided that it no longer met the criteria for city status. This was rectified on 14 March 2012, when Perth was reinstated as an official city, as part of the Queen's Diamond Jubilee celebrations.

Perth is central to Scotland and its history, and, today, it is a charming historic city that retains much of its ancient character and architectural quality. Modern-day Perth is a thriving city, and its retail centre has an attractive pedestrianised high street and a wide variety of shops, cafés, museums, galleries, restaurants and pubs.

The Royal Mail first allowed picture postcards to be sent through the post in 1894. Only the address of the recipient was allowed on the undivided back of the cards, as it was considered unseemly for messages to be openly displayed. In 1902, the first divided back postcards with space for a message were published. This combined with increasing levels of literacy, some increase in holiday entitlement for workers and improved public transport resulted in a boom

period for the picture postcard, which lasted until the outbreak of the First World War in 1914. A swift mail service with multiple daily deliveries also meant that they were a speedy method of communication – the email of their time. The advent of fairly affordable cameras after the First World War resulted in a decline in the popularity of picture postcards.

Old picture postcards are an invaluable visual record of a place's past and provide a fascinating insight into the world of our ancestors. The old postcards of Perth celebrate the town's civic achievements and distinctive character in the form of public buildings, principal streets, parks, railway stations, historic landmarks, libraries, hospitals and significant events. A number of the postcards were produced by J. B. White Ltd, a Dundee-based company, which first started to publish picture postcards in 1907.

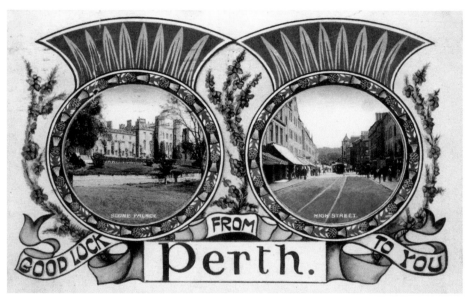

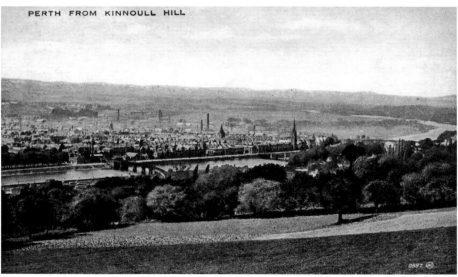

CHAPTER 1
CITY STREETS

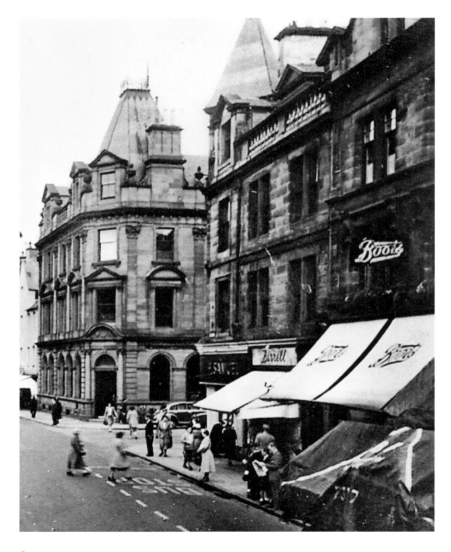

Streets

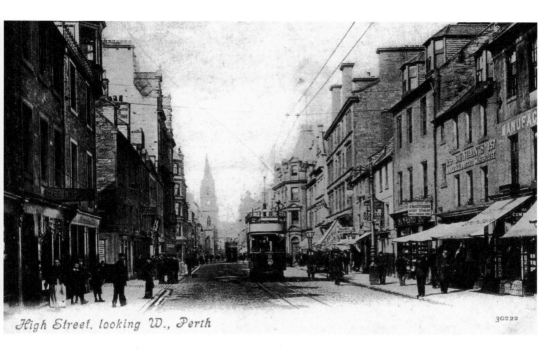

High Street, looking W., Perth 30222

High Street Looking West

Two views of the High Street with the tower of St Paul's Church in the background. Perth developed on a plan of two parallel streets, the High Street and South Street, linked by a warren of lanes or vennels leading north and south. The names of these vennels have historic origins and many, such as Cow Vennel and Fleshers Vennel, reflect the trades associated with them in the past. The original old buildings were redeveloped with tenements, shops and businesses in the late eighteenth and early nineteenth centuries.

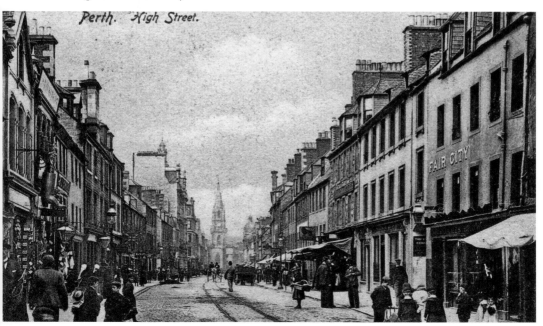

Perth. High Street.

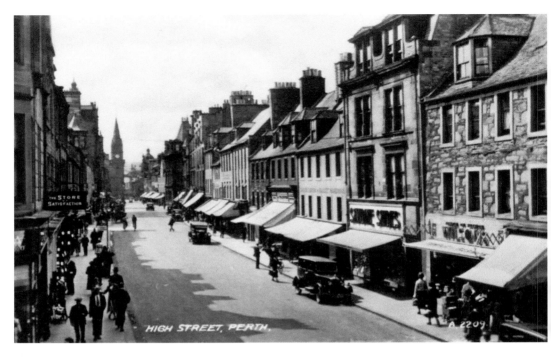

High Street Looking West

These are two other postcard views looking west on the High Street. There has been considerable redevelopment between the dates of these two images. The Store of Satisfaction on the corner with King Edward Street has been replaced by a Debenham's shop.

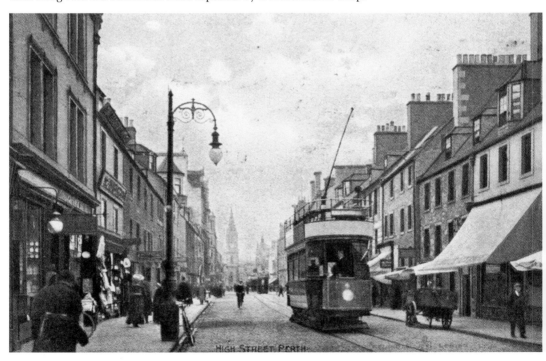

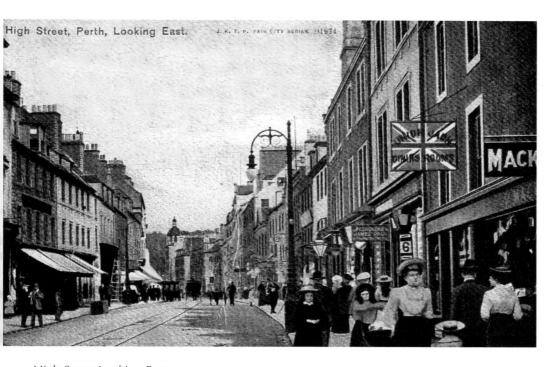

High Street Looking East

These views are looking east on the High Street, with the dome of the General Accident Fire and Life Assurance Corporation in the background. King Edward Street, which opened in 1902, is missing from the images.

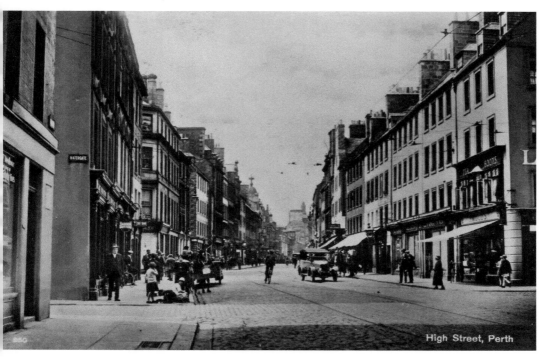

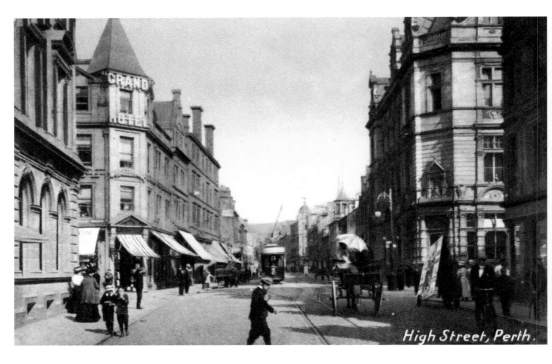

High Street

In the Perth Street Directory of 1903, the Grand Hotel was advertised as the most central hotel in Perth. The hotel offered dinners for two shillings and provided 'every comfort for cyclists'.

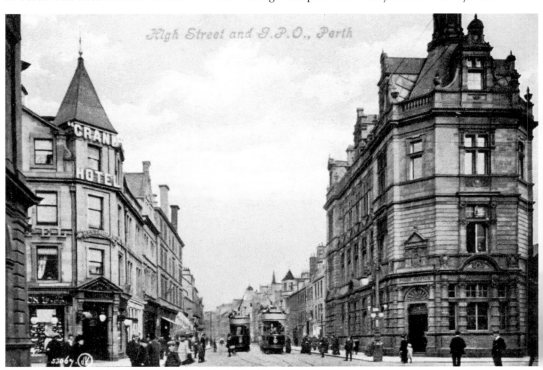

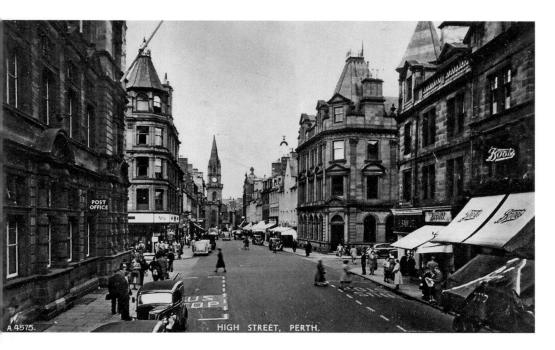

HIGH STREET, PERTH.

High Street

These views are looking west on the High Street, with Kinnoull Street to the right and Scott Street to the left. The post office switched sides of the street between the dates of the images. The building that it occupied on the left side of the images is the only noteworthy redeveloped building on this stretch of the High Street. The pedestrianisation of the street has made a significant difference to the environment of the High Street.

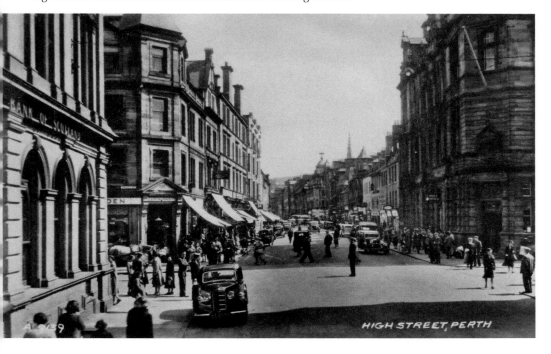

HIGH STREET, PERTH

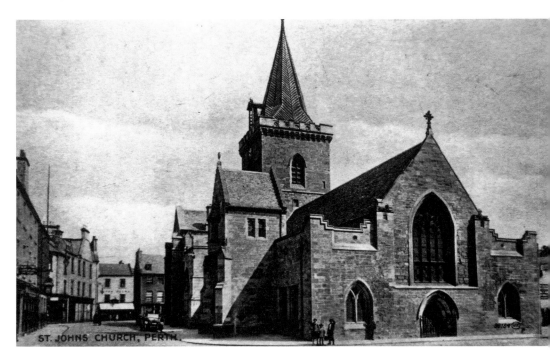

ST. JOHNS CHURCH, PERTH.

St John Street

St John Street was developed in the early nineteenth century on the line of the old Ritten Row to improve access to the new bridge. It is lined by elegant terraces with ground floor shops and has St John's Kirk as a centrepiece.

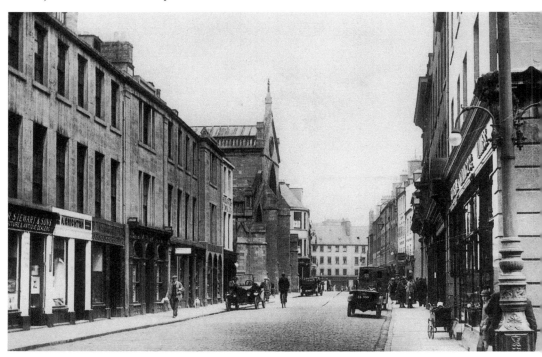

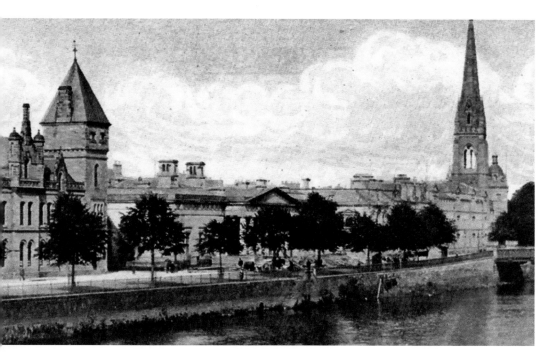

Tay Street

The Watergate was old Perth's most impressive street, lined by fine houses with long narrow garden plots stretching down to the Tay. It rapidly lost its status when Tay Street, the new grand boulevard along the bank of the river, was opened in the mid-1870s. The clutter of medieval backlands was removed and the city presented an imposing new frontage to the river.

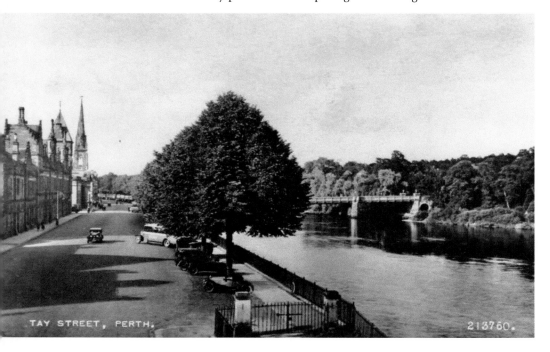

TAY STREET, PERTH. 213760.

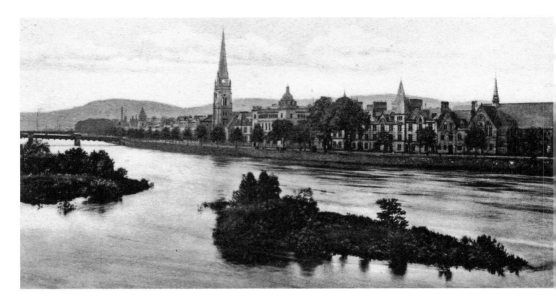

Tay Street

St Matthew's Church spire dominates these views. The building to the right of the images is the former Middle Church, dating from 1887, with the former Council Chambers adjoining. On the opposite side of the High Street the building with the corner dome was the former offices, dating from 1899, of the General Accident Fire and Life Assurance Corporation. General Accident moved out of this building in 1983 and it was converted into the council headquarters. General Accident was founded in 1885 by a group of local farmers and developed rapidly into an insurance giant. The embankment wall was replaced during flood defence work in 1999.

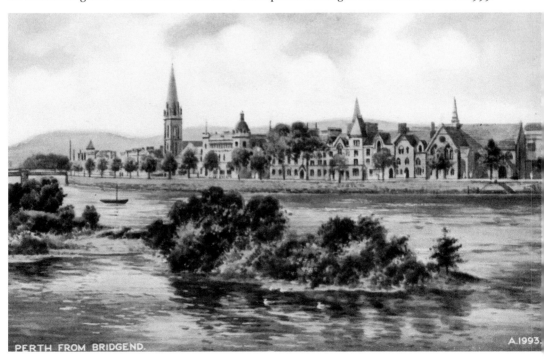

PERTH FROM BRIDGEND. A.1993.

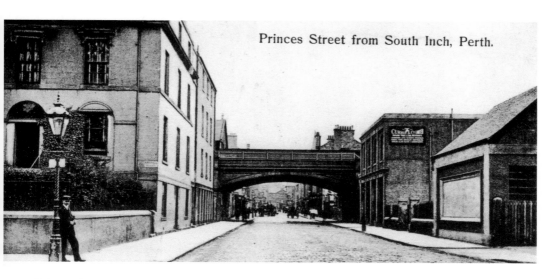

Princes Street from South Inch, Perth.

Princes Street

Princes Street was developed in the late eighteenth century to link the Edinburgh Road with the new bridge. Princes Street railway station opened on 24 May 1847 on the Perth to Dundee main line. It closed to regular passenger traffic on 28 February 1966. The railway line passes behind Marshall Place and is carried over cross streets by a series of bridges.

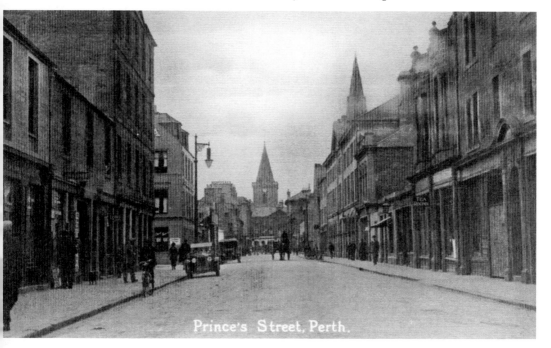

Prince's Street, Perth.

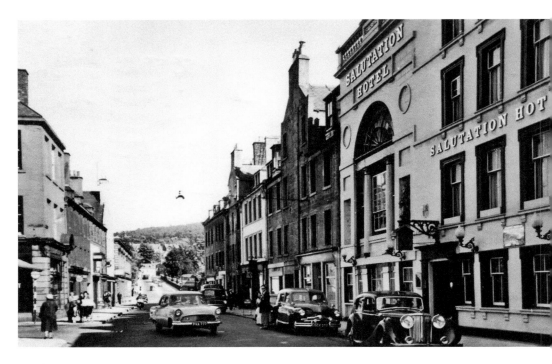

South Street

South Street was once the site of Perth's weekly shoe market and was known as the Shoe Gait. It was originally terminated at its east end by Gowrie House. Direct access to the river was made on the demolition of the house in the early nineteenth century and South Street became a busy through route when the Victoria Bridge was opened in 1900.

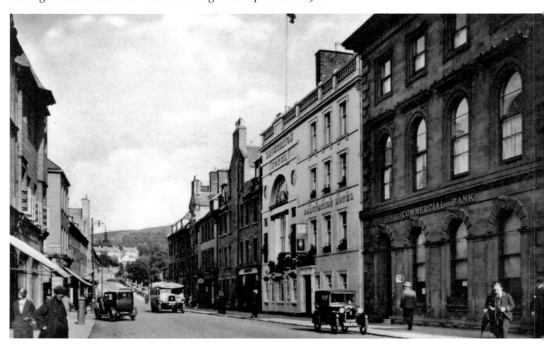

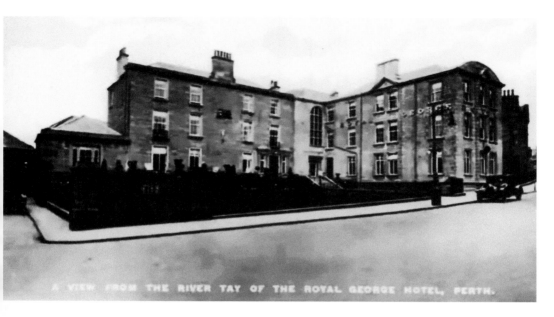

A VIEW FROM THE RIVER TAY OF THE ROYAL GEORGE HOTEL, PERTH.

George Street

George Street was opened as a planned street in 1771 to provide access to the new bridge. It is named after George III. The George Hotel opened in 1773. It originally served as a coaching inn with stabling for mail coaches. Queen Victoria arrived for a surprise overnight stay at the hotel on 29 September 1848. The queen had never stayed in a hotel before and was so impressed by the welcome she received that she granted the hotel a royal warrant.

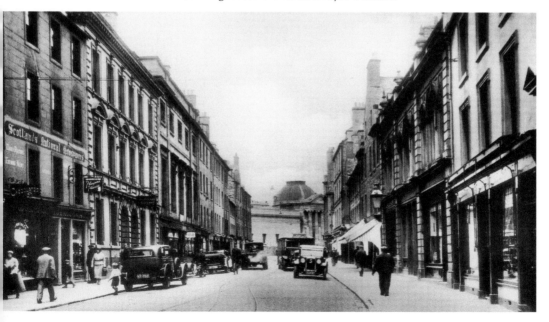

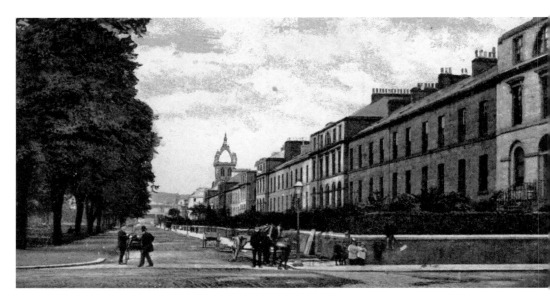

Marshall Place

> It is impossible to turn the eye to any quarter of Perth without some remarkable remembrance of Provost Marshall. He had a particular pleasure in planning and a particular energy in carrying out whatever appealed to him calculated to adorn, improve or in any way beneficial to his native town.
>
> (*Scots Magazine*, 1808)

Marshall Place takes its name from Provost Thomas Hay Marshall (1768–1808), who was a Baillie at age twenty-two and twice provost. Marshall was the inspiration behind many improvements to Perth, including the development of numerous new streets of elegant Georgian architecture.

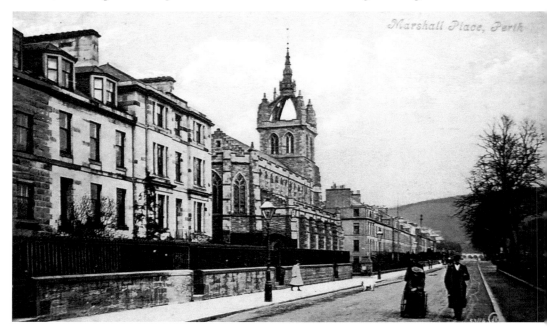

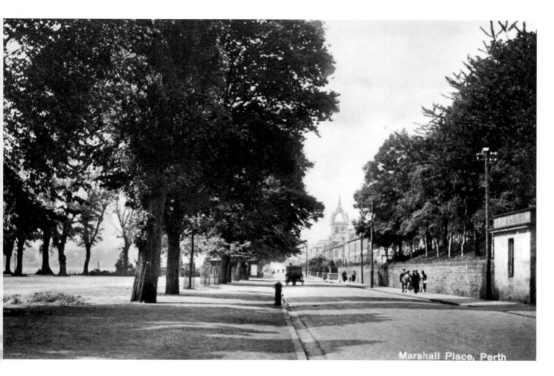

Marshall Place, Perth

Marshall Place

The street of smart Georgian houses comprises two symmetrical palace fronted blocks that overlook the South Inch. They were designed by the eminent architect Robert Reid. They were built from 1806 and were intended to be the first part of a grand scheme to create a Southern New Town of Georgian terraces. However, they were not completed until 1833 due to legal and financial issues.

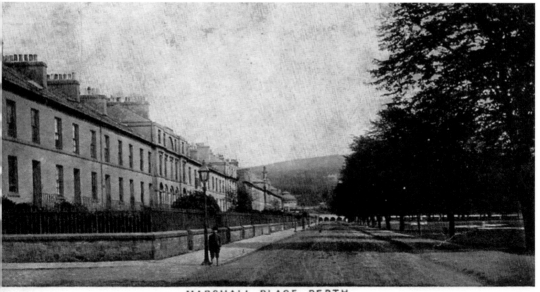

MARSHALL PLACE, PERTH.

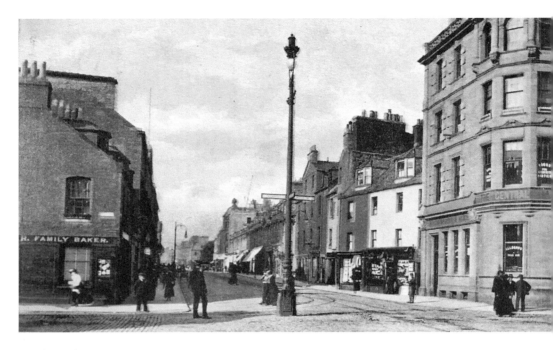

South Methven Street

Views looking along South Methven Street, with County Place on the left and South Street on the right. Both of these images predate 1929, when the Perth's electric trams were closed. The area was the site of the South Street Port, a gate in the town wall. The prominent building with the octagonal corner spire on the corner with South Street dates from 1901. The original design incorporated the ground-floor pub, which was the Central Bar for decades and is now the Dickens pub.

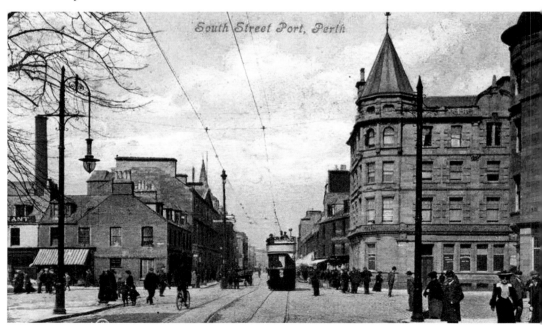

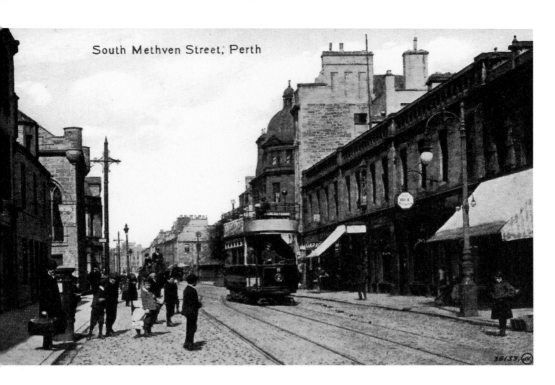

South Methven Street, Perth

South Methven Street
South and North Methven Street followed the line of the town lade and was Perth's historic
western boundary.

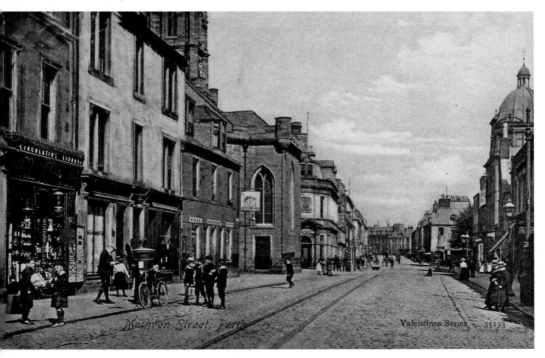

Methven Street, Perth Valentines Series 35133

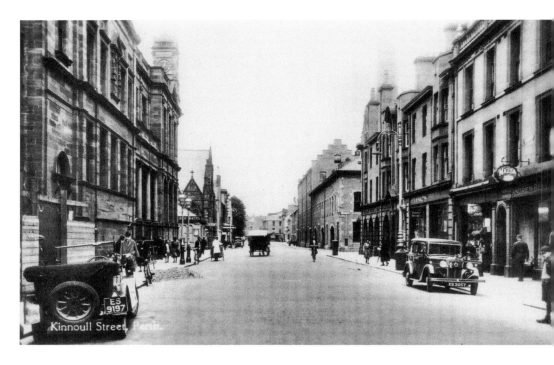

Kinnoull Street

Kinnoull Street was laid out in 1823. The wider view shows the former Sandeman Library on the left side of the street and the enormous Pullar's North British Dyeworks in the right background. The Congregational Church is to the right of the former Sandeman Library.

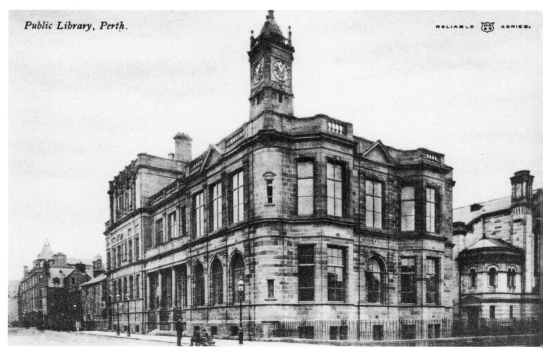

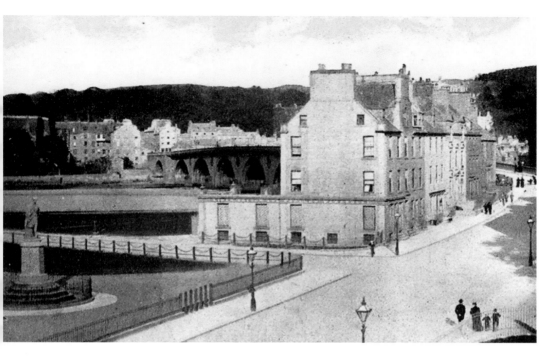

Charlotte Street

Charlotte Street was laid out with ordered elegant buildings in 1783. A plaque on the wall at the corner of Charlotte Street and Atholl Terrace marks the location of the Blackfriars Monastery. It also commemorates the Battle of the North Inch and the murder of King James I at the monastery in 1437.

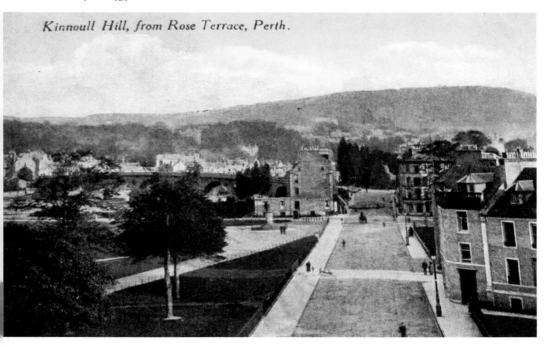

Kinnoull Hill, from Rose Terrace, Perth.

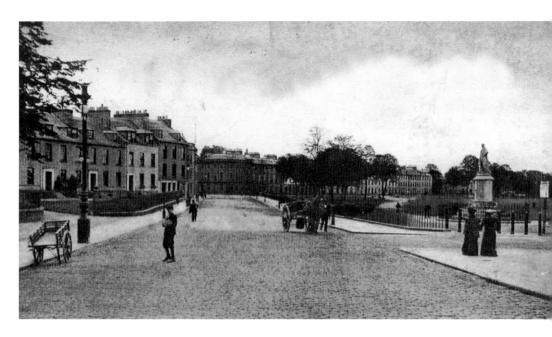

Rose Terrace

Rose Terrace was one of the most elegant terraces in the Thomas Hay Marshall-inspired development of Perth towards the end of the eighteenth century. It forms an impressive edge to the North Inch. It was named for Thomas Hay Marshall's wife and Marshall's own house was on the corner with Atholl Street. The Old Academy opened in 1807 and forms the centrepiece of the terrace. The distinctive sculpture of Britannia and the clock on the parapet were added in 1886. The building ceased to function as a school when the academy moved to new premises in Viewlands Terrace in 1932.

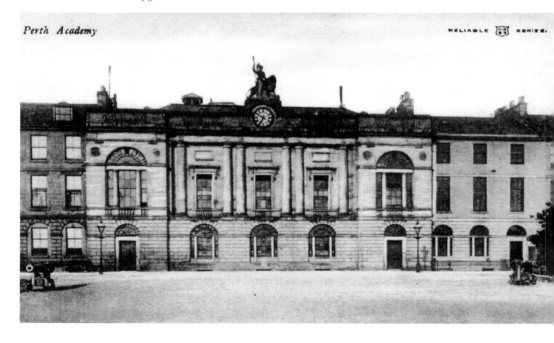

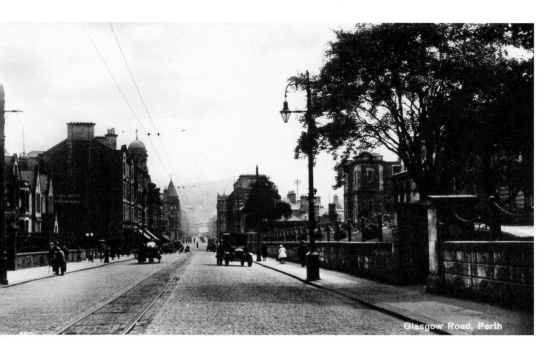

Glasgow Road, Perth

York Place

Views looking east on York Place. In the coloured image, the public bar sign for the Waverley Hotel is prominent in the left foreground and a sign on the railings at the corner with Caledonia Road provides directions to the Station Hotel. Trinity Church, which dates to 1860 and has twin towers capped by tall pyramidal roofs, stands next to the Waverley Hotel. The old infirmary building is to the right of the images.

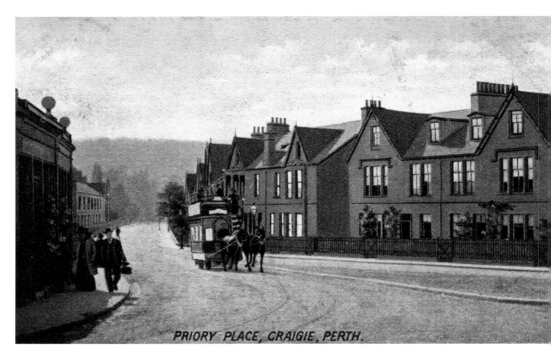

PRIORY PLACE, CRAIGIE, PERTH.

Priory Place, Craigie

These images span the period between the Perth's horse-drawn tram service and the advent of the electric trams. The level of Priory Place was raised to allow traffic to cross the St Leonard's Bridge.

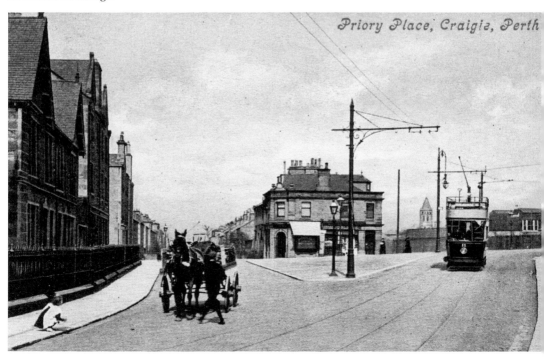

Priory Place, Craigie, Perth

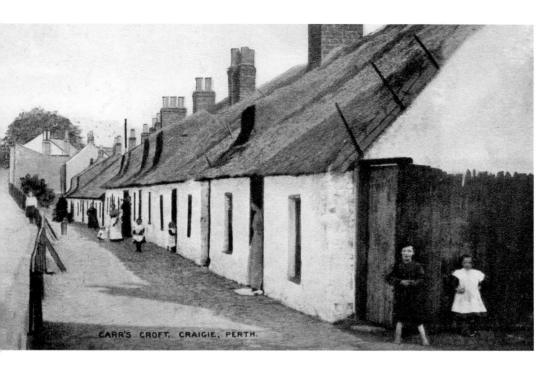

CARR'S CROFT, CRAIGIE, PERTH.

Priory Place, Craigie
Carr's Croft was a row of thatched cottages that originally stood on the east side of Priory Place. The site is now a plumber's yard and one of the original cottages just survives in a derelict condition.

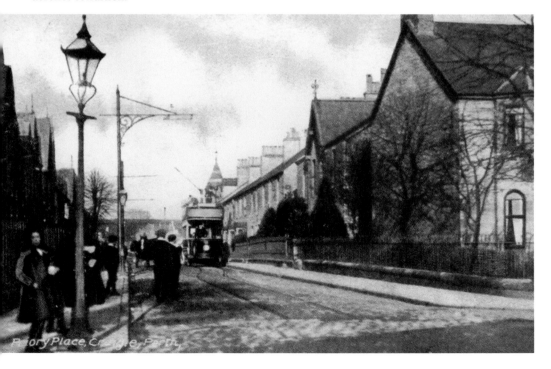

Priory Place, Craigie, Perth.

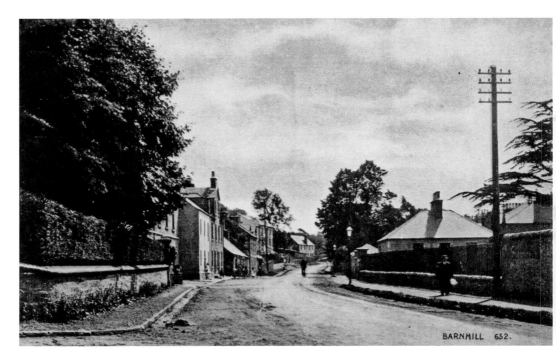

BARNHILL 652.

Barnhill

Villages, such as Barnhill, on the east bank of the Tay were relatively isolated from the town until Smeaton's Bridge was built in the 1770s. Barnhill developed substantially from a small number of sparse cottages when the new Perth to Dundee turnpike road opened in 1829. Barnhill Sanatorium was opened in 1901.

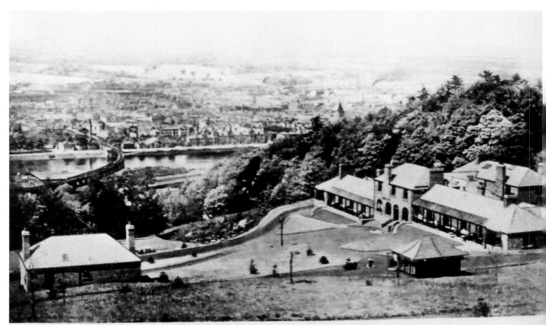

CONSUMPTIVE SANATORIUM. BARNHILL. PERTH.

CHAPTER 2
LANDMARKS

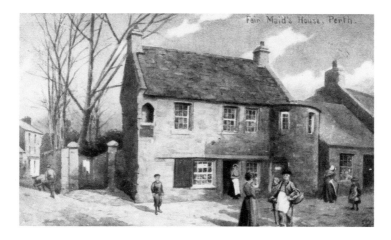

Fair Maid's House, North Port Street

The Fair Maid's House has fifteenth-century origins and is the oldest surviving non-religious building in Perth. In 1693, the building was purchased by the Glover Incorporation of Perth and was used as their meeting place for 150 years. The house takes its name from Sir Walter Scott's 1828 novel *The Fair Maid of Perth*, in which the building features as the home of Catherine Glover, 'the Fair Maid'. Perth has been known as the 'Fair City' since the publication of the novel.

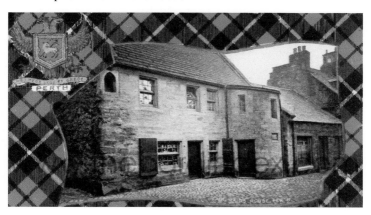

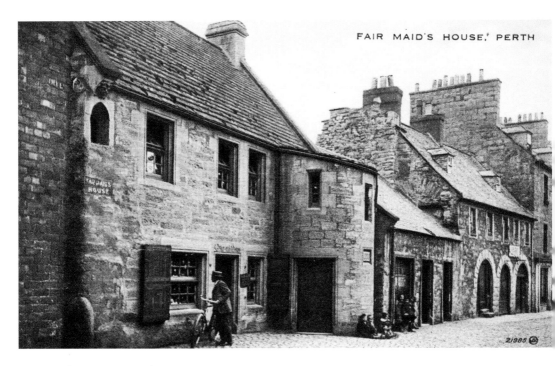

Fair Maid's House, North Port Street
A head is carved on the gable end of the building and the motto of the Glover's, 'Grace and Peace', over the entrance door. The niche on the outside is said to have contained the curfew bell or a statue of St Bartholomew, the patron saint of the Glovers.

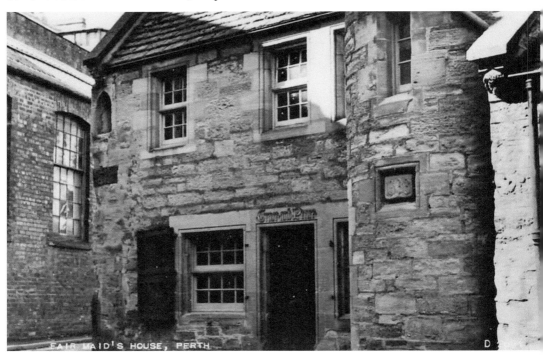

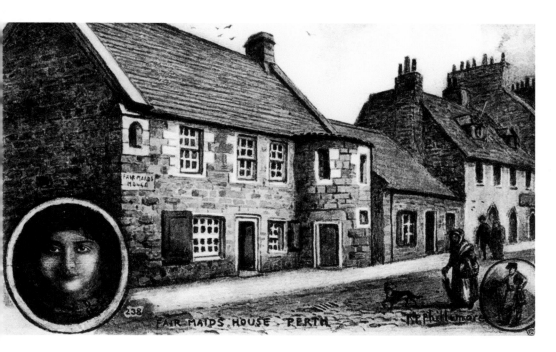

Fair Maid's House, North Port Street

A plaque on the building that adjoins the Fair Maid's House notes that it was the site of the town house occupied by Lord John Murray, Member of Parliament for Perthshire from 1734 to 1761, who was appointed General of HM Forces in 1770. Both buildings are now occupied as a centre for geographical and environmental education by the Royal Scottish Geographical Society.

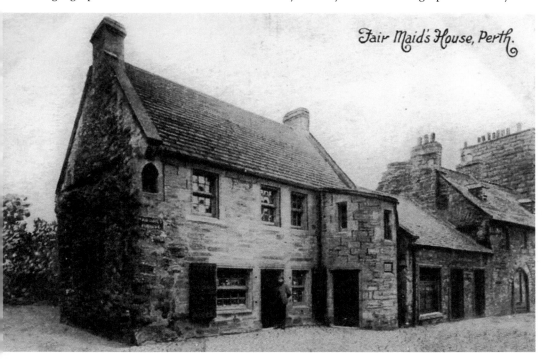

Fair Maid's House, Perth.

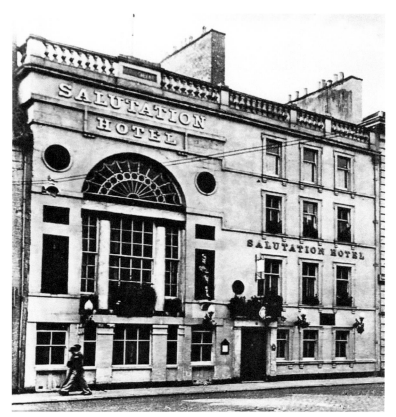

Salutation Hotel, South Street
The Salutation Hotel lays claim to being the longest established hotel in Scotland. It was a coaching inn between 1699 and 1745, and was the main resting point on the coach roads from Edinburgh and Glasgow to Aberdeen and Inverness. The name, the Salutation, is said to derive from John Burt, an early landlord, having shaken hands with Prince Charlie, who stayed at the hotel in 1745.

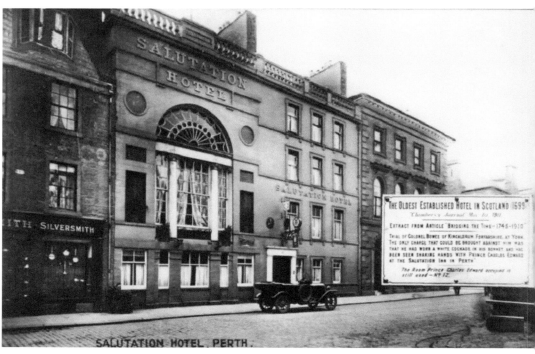

SALUTATION HOTEL, PERTH.

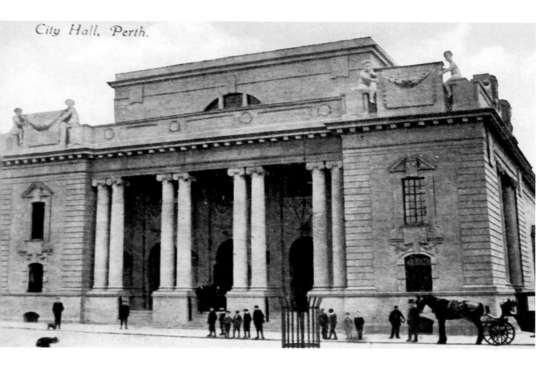

City Hall, Perth.

Perth City Hall, King Edward Street

King Edward Street was completed in 1902 as a new street linking the High Street and South Street. The new City Hall was opened on 29 April 1911. Its imposing baroque frontage with giant Ionic columns dominates the east side of the street. The hall has been disused since Perth's new concert hall opened in 2005 and, at the time of writing, the building's future is uncertain.

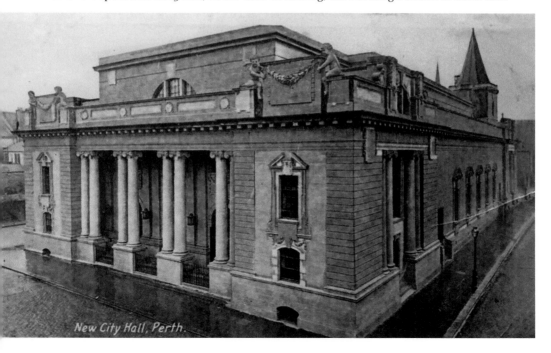

New City Hall, Perth.

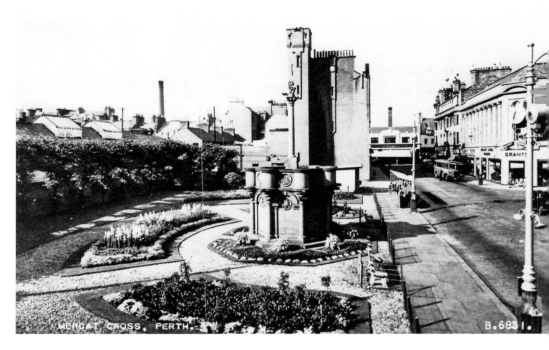

Perth Mercat Cross, King Edward Street

Perth's early mercat cross stood on the High Street opposite Skinnergate. The cross was removed in 1651 by Cromwell in order to get stones for his citadel. Another cross was erected in 1669, but it proved an obstruction to traffic and was removed in 1765. The present cross in St John's Square was erected in 1913 as a memorial to Edward VII.

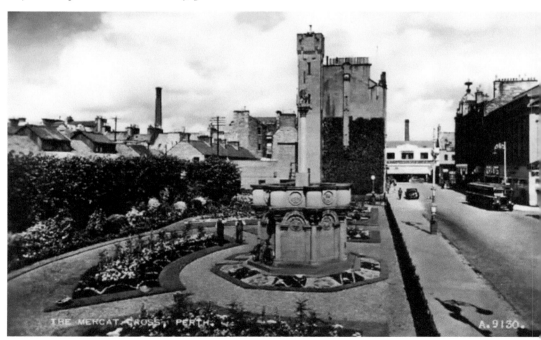

Perth Prison, Edinburgh Road

Perth Prison was built between 1810 and 1812 to accommodate French prisoners captured during the Napoleonic War. The prison regime was generally fairly relaxed – the prisoners ran a market that was open to everybody and the officers were allowed to stay with local families, provided they promised not to escape. The French prisoners were returned to France after the Battle of Waterloo in 1815 and a large crowd of locals gave them an emotional send off. Between 1815 and 1839, the building was used as a military clothing store. In 1840, it became a civilian prison and is the oldest prison still in use in Scotland.

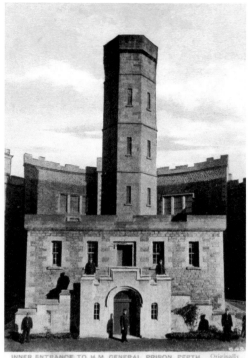

INNER ENTRANCE TO H.M. GENERAL PRISON, PERTH. Originally erected for the detention of French prisoners of war in 1812. The pulleys for the drawbridge still remain over the porch.

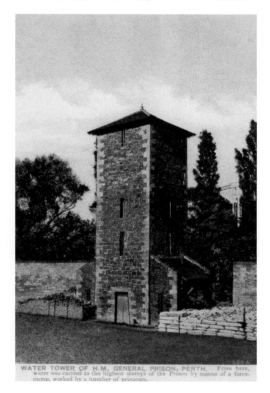

WATER TOWER OF H.M. GENERAL PRISON, PERTH. From here, water was carried to the highest storeys of the Prison by means of a force pump, worked by a number of prisoners.

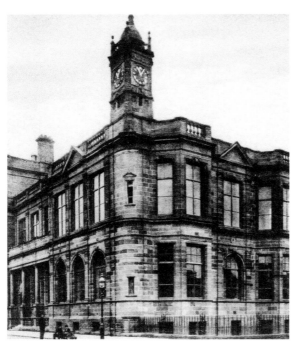

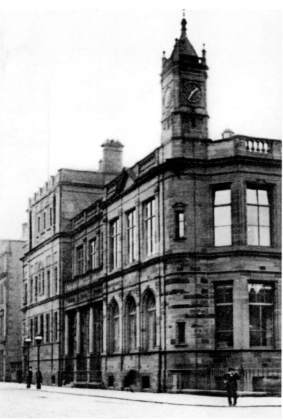

Former Sandeman Library, Kinnoull Street

Professor Archibald Sandeman of Queen's College, Cambridge, came from a local family and bequeathed £30,000 to establish a free public library in Perth. The opening ceremony of the library in October 1898 was performed by the Earl of Roseberry. The Sandeman Library closed in 1994 when the AK Bell Library opened in the refurbished former infirmary building. The building, with its distinctive corner clock tower, is now occupied by the Sandeman public house.

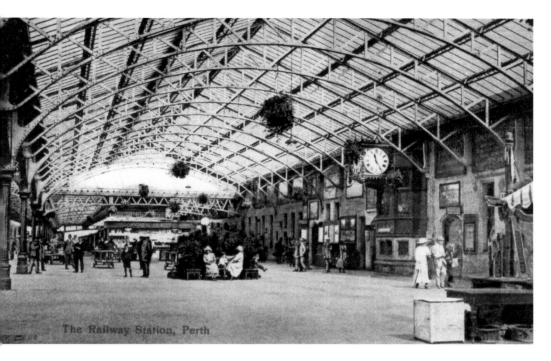

The Railway Station, Perth

Perth Railway Station, Leonard Street

Perth railway station was opened in 1848 by the Scottish Central Railway. The station was extended in 1866 and largely reconstructed in 1886. John Menzies opened one of its first bookstalls at Perth station in May 1857. The station developed as a main hub on the Scottish rail service.

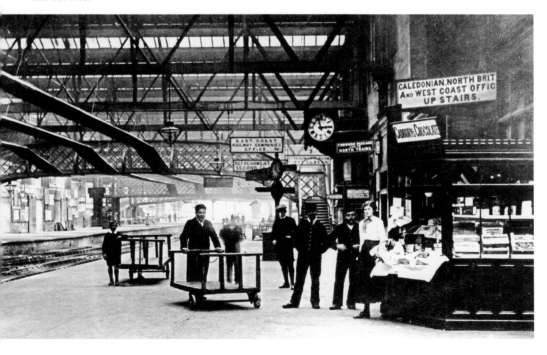

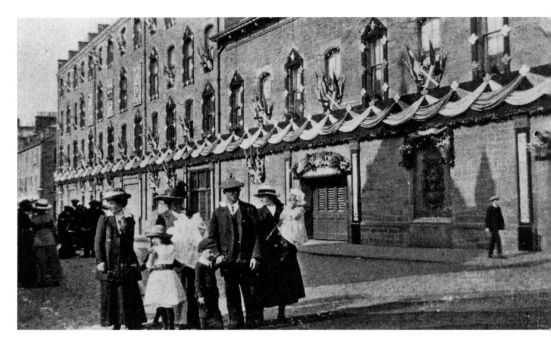

J. Pullar & Sons of Perth

John Pullar announced the opening of his gingham dyeing business in Burt's Close with an advert in the *Perth Courier* in 1824. Robert Pullar (1828–1912), James' son, expanded the company. They were the first company to provide a dry-cleaning service in Britain and pioneered the use of synthetic dyes. The company operated the largest dry-cleaning machine in the world, capable of cleaning carpets measuring 100 yards square. The company was taken over by Eastman & Sons, although continuing to trade under the Pullar's name. The Pullar's building was converted to office use in 2000.

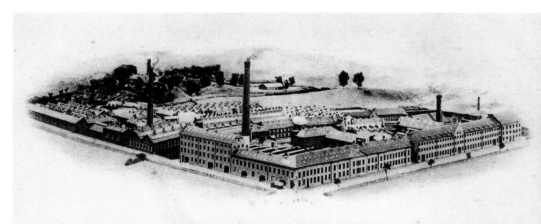

PULLARS of PERTH

WORLD'S LARGEST CLEANING & DYEING WORKS

In all the processes of Dyeing and Cleaning the name of Pullar has for four generations been unrivalled for quality of work, and to-day the reputation of the name is higher than ever. Prices are moderate, service prompt and efficient.

BRANCHES AND AGENCIES EVERYWHERE

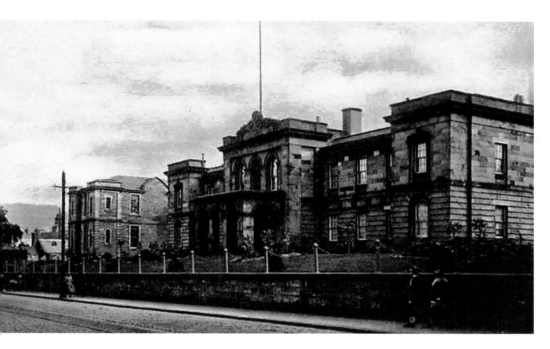

Infirmary/Library, York Place

The old infirmary building was designed by William Macdonald Mackenzie (1797–1856), Perth's city architect for thirty years, and opened as the County and City Infirmary in 1837. It was the main hospital for the district until the Perth Royal opened in 1914. During the First World War, it was a Red Cross hospital, tending for war wounded. It was then used as council offices until it was converted into the AK Bell Library in 1994.

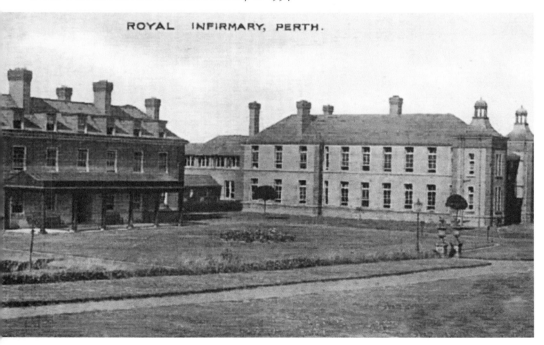

ROYAL INFIRMARY, PERTH.

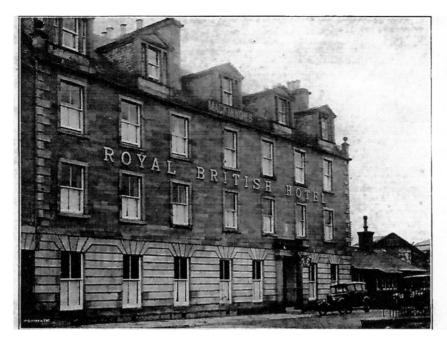

THE
ROYAL
BRITISH
HOTEL,
PERTH

TELEPHONE
NO. 315.

Royal British Hotel, Leonard Street

The classical style building was built as a hotel and dates from the mid-nineteenth century. In 1901, it was being advertised as 'an old-established first-class family and commercial hotel famed for its excellent cuisine, which is pronounced by all to be one of the most comfortable hotels north of the Forth.' It would have benefited from the large numbers of passengers travelling through the nearby Perth station. The hotel was converted into flats in 1995.

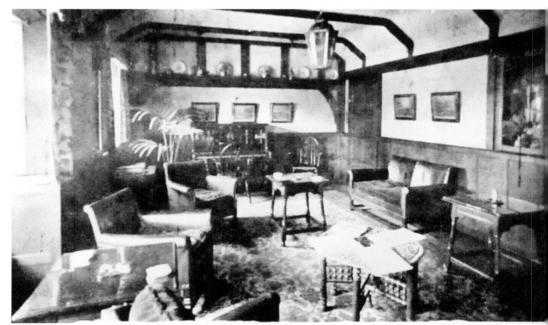

A CORNER OF THE LOUNGE, ROYAL BRITISH HOTEL, PERTH

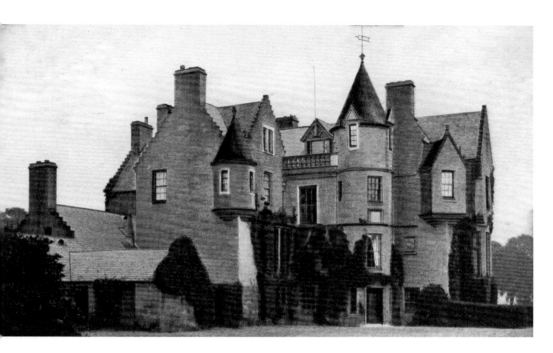

Balhousie Castle, Hay Street

Balhousie Castle has its origins in a twelfth-century castle owned by the Earls of Kinnoull. The current building is an 1860's baronial-style remodelling of a later seventeenth-century tower house. Over the centuries the castle has been occupied by a number of eminent Perth families. From 1926 until 1940, the building was in use as a convent. During the Second World War, and for some time after, it was used by the army. In 1962, the castle was converted into the Regimental Museum of the Black Watch.

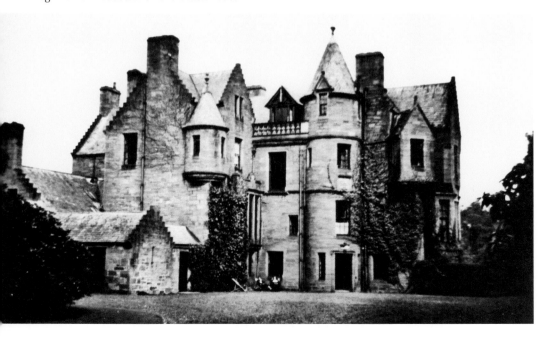

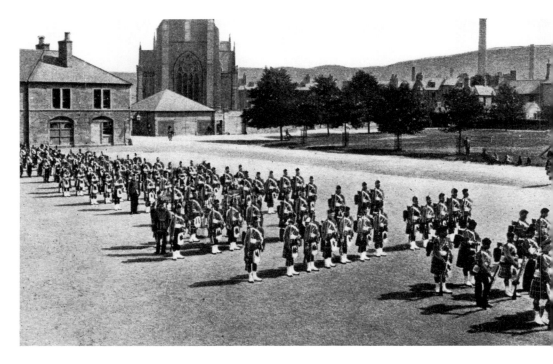

The Queen's Barracks

The Queen's Barracks were built in 1792 and occupied a large site to the west of St Ninian's Cathedral. The barracks served as the depot for the Black Watch from 1830 until 1961. The barracks were demolished and the site was redeveloped for the new police headquarters, the inner ring road and a sheltered housing complex.

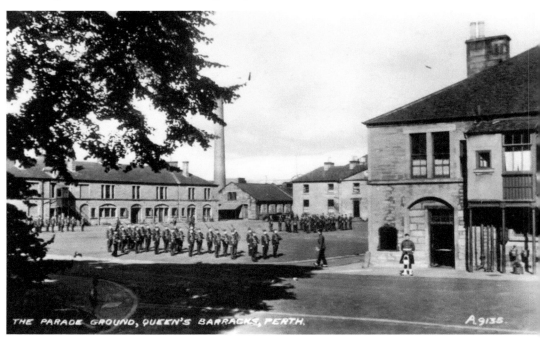

THE PARADE GROUND, QUEEN'S BARRACKS, PERTH. A.9138.

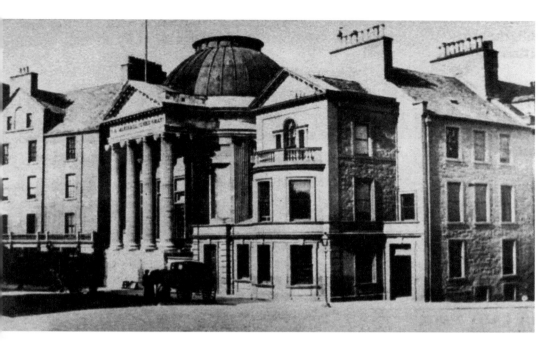

Perth Museum and Art Gallery

The Perth Museum and Art Gallery, with its massive Roman Ionic portico and domed rotunda, was opened in 1824 as the Marshall Monument by the Literary and Antiquarian Society of Perth. It is modelled on the Pantheon in Rome. The new building was dedicated to the memory of Provost Thomas Hay Marshall (1780–1808). Provost Marshall was responsible for the innovative reconstruction programme for Perth. An extension to the original building was opened by the Duke and Duchess of York on 10 August 1935.

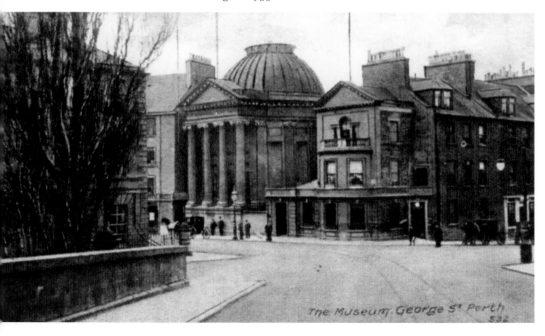

The Museum, George St Perth

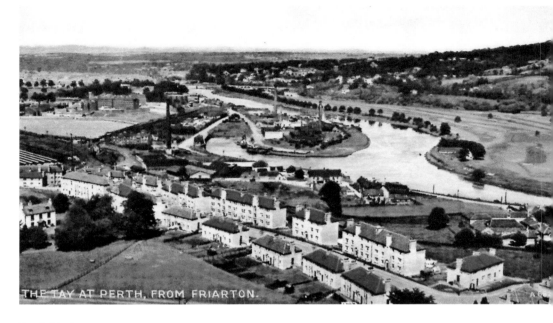

THE TAY AT PERTH, FROM FRIARTON.

Perth Harbour

Perth is located at the highest navigable point on the Tay and the town has been an important harbour since medieval times. The harbour was originally closer to town at the foot of the High Street, but harbour sites moved south as the sand and gravel banks of the river changed shape and as ships became bigger and needed deeper water. A number of small shipyards also operated in the harbour area until the decline of the business in the late nineteenth century. The present harbour at Friarton was started in 1840 to a design by Robert Stevenson.

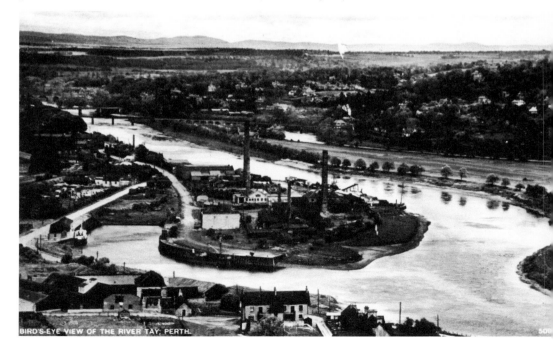

BIRD'S-EYE VIEW OF THE RIVER TAY, PERTH.

CHAPTER 3
BRIDGES AND BRIDGEND

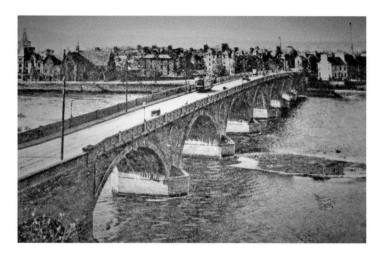

Perth Bridge

Until the nineteenth century, Perth was the lowest crossing point of the Tay. In 1209, a bridge at the foot of Perth High Street was swept away by floods. It was rebuilt soon afterwards and there are records of repairs being made to it in the ensuing centuries. However, by the end of the sixteenth century it was clear that a new bridge was needed.

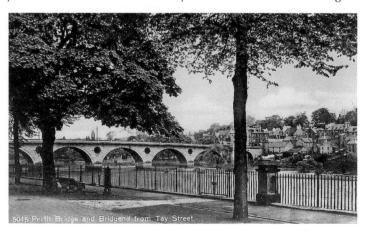

5045 Perth Bridge and Bridgend from Tay Street.

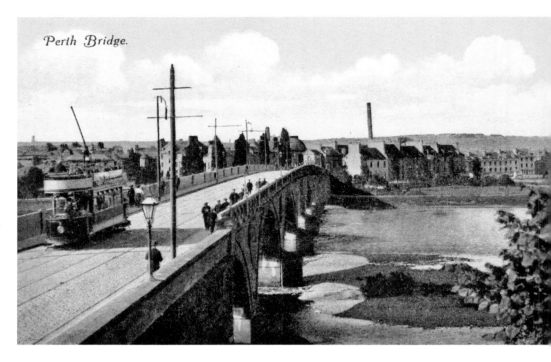

Perth Bridge.

Perth Bridge

In 1604, John Mylne, the king's master mason, was engaged to design a new crossing. This opened in 1616, but was washed away during three days of violent storms in 1621. For the next 150 years, there was no bridge and crossings of the Tay were made by ferry boat services, which could be hazardous in the fast-flowing waters of the river.

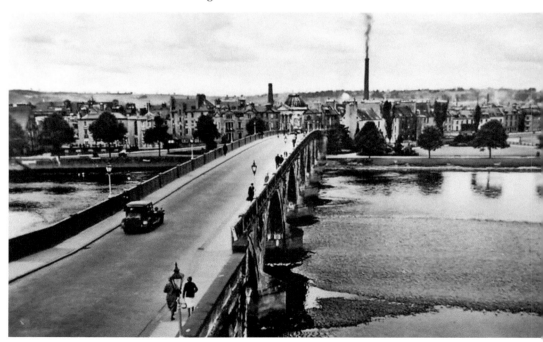

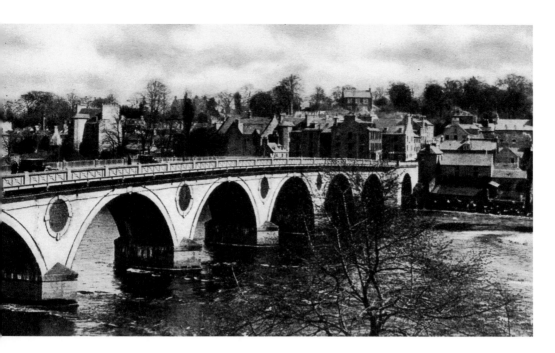

Perth Bridge

The idea for a new bridge crossing was promoted by Thomas Hay, 9th Earl of Kinnoull (1710–87), and, in 1765, an Act of Parliament approved the construction of the bridge. Eminent engineer John Smeaton (1724–92), who is regarded as the 'father of civil engineering', was appointed to design the bridge, which was completed in October 1771. Smeaton's elegant nine-arch bridge in local sandstone was, at 272 metres (893 feet), the longest in Scotland when it opened. It cost £26,631, which was met by the government from seized Jacobite funds and public subscriptions.

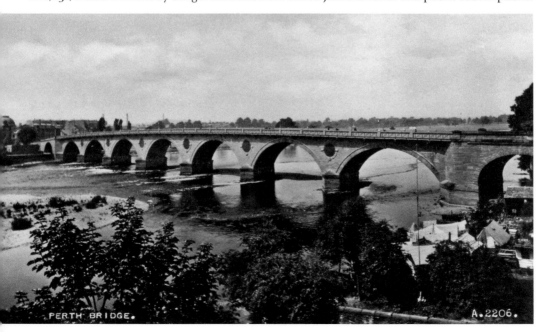

PERTH BRIDGE. A.2206.

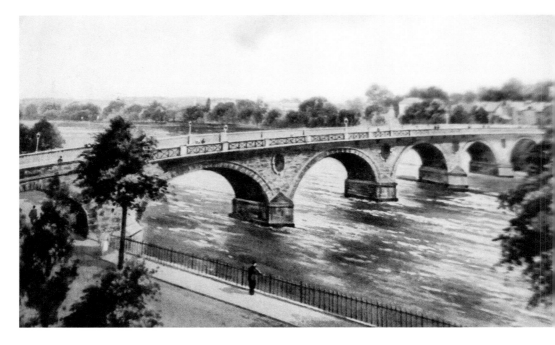

Perth Bridge

The bridge was designed to withstand the highest level spates on the Tay and was tested some three years after it opened when ice blocked the river and parts of the town were flooded. The bridge stood firm and has survived many subsequent floods. The bridge was widened in 1869 to cope with increased traffic – the stone parapets and cantilevered footpaths were added at that time.

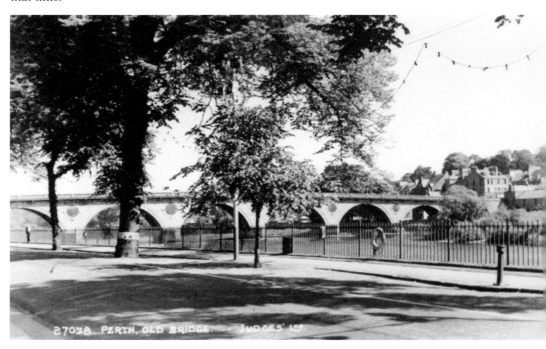

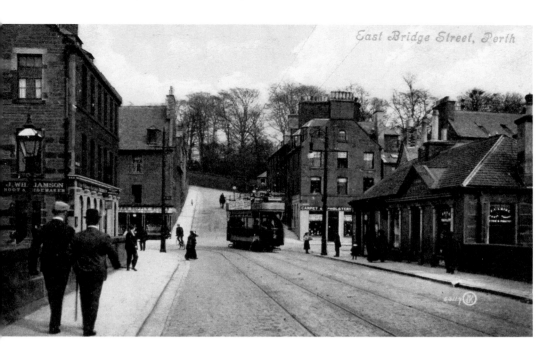

East Bridge Street, Perth

Bridge Tollhouse

A halfpenny toll was charged until 1883 and a sign, dated 1879, on the outside of the old tollhouse, specifies the bridge rules: 'Be it enacted that no locomotive shall pass upon or over Perth Bridge between the hours of 10am and 3pm and that at other times the person in charge of such locomotives shall send a man with a red flag to the opposite end of the bridge from that on which he is to enter, warning all persons concerned of the approach of the locomotive before it shall go upon the bridge.'

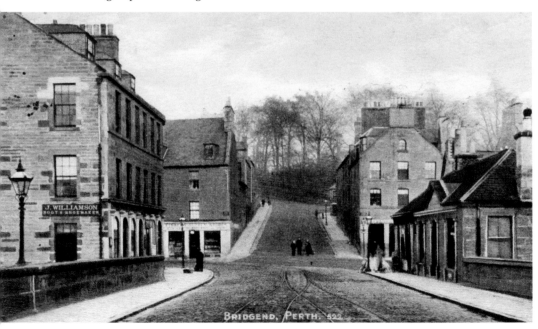

BRIDGEND, PERTH. 522

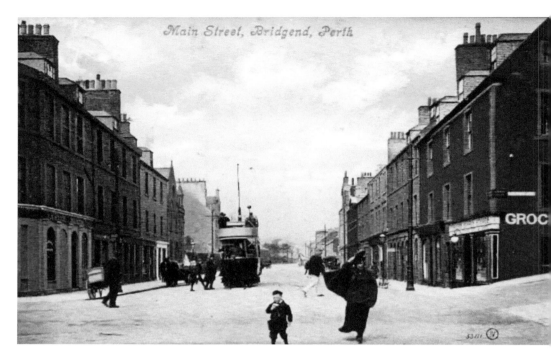

Bridgend

Bridgend was a busy ferry crossing and the base of ferrymen who worked on the river before Smeaton's Bridge opened in 1771. There was a settlement at Bridgend from at least the sixteenth century, although the Statistical Account of Scotland (1791–99) notes that 'before the new bridge was built, Bridgend was a poor paltry village'.

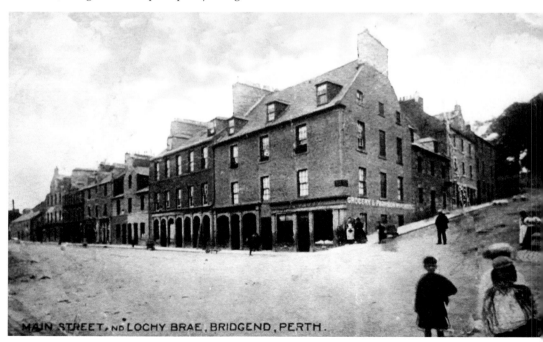

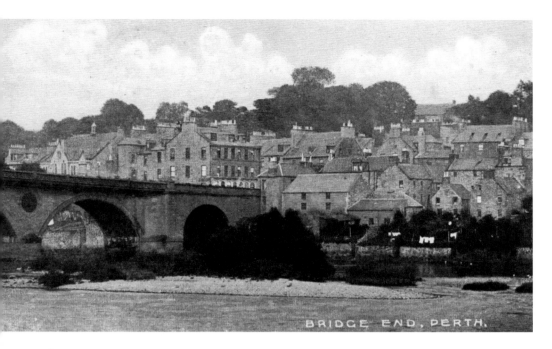

BRIDGE END, PERTH.

Bridgend

Bridgend consisted chiefly of a few cottages occupied by the boatmen employed on the ferry. The erection of the bridge in 1771 was the sole cause of the large and progressive increase in size which has taken place. It is richly studded with villas, which, from the striking position many of them occupy, contribute in no small degree to the picturesque beauty of the landscape which bursts upon the eye, when Perth and its environs are first seen on approaching them from the south.

(New Statistical Account of Scotland, 1845)

Bridgend Perth.

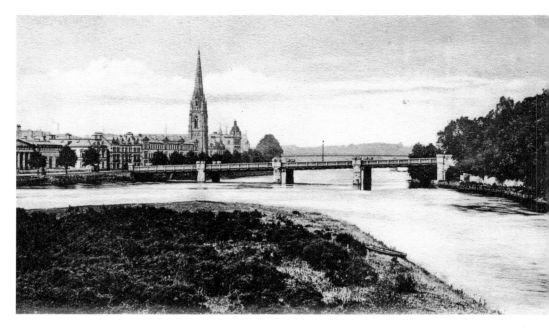

Victoria Bridge

As road traffic built up at the end of the nineteenth century, it was clear that a second crossing of the Tay was required to relieve pressure on the Old Bridge. The Victoria Bridge, linking South Street to Dundee Road, was opened by Lady Pullar in 1900. It was a steel truss bridge spanning between concrete piers. Construction of the bridge was delayed by protracted negotiations with the owner of a villa, Rodney Lodge, which was in the direct line of the new bridge on the east bank. The house was eventually compulsory purchased, but the owner left the gables standing each side of the new bridge as a protest.

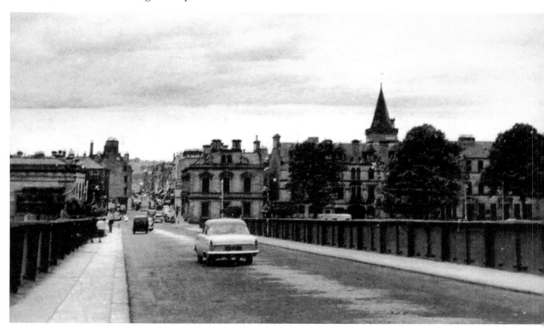

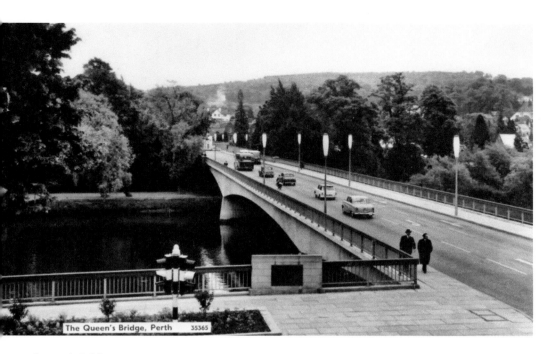

The Queen's Bridge, Perth 35365

Queen's Bridge

The Queen's Bridge was opened by the Queen on 10 October 1960 as a replacement for the Victoria Bridge. The date was significant as the 750th anniversary of the granting of the royal charter of 1210 to Perth. It is a light and graceful structure of shallow arches. The old bridge was ingeniously raised up and the new prestressed concrete bridge slotted in beneath it to allow traffic to keep crossing the Tay.

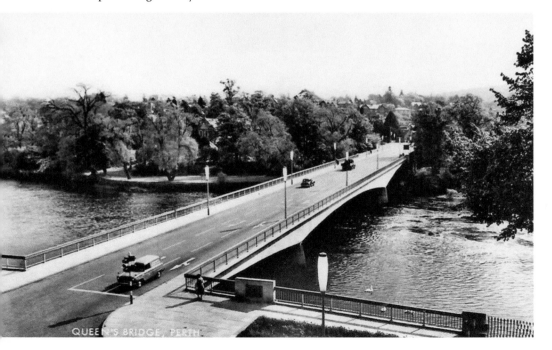

QUEEN'S BRIDGE, PERTH

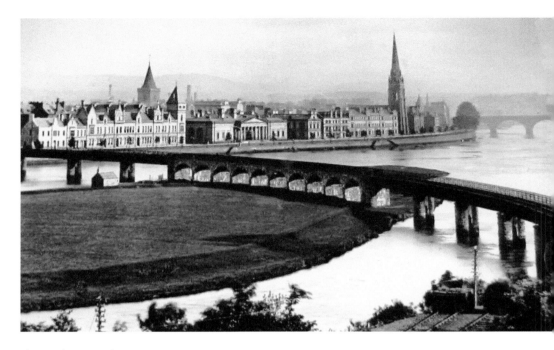

The Railway Bridge

The view of Perth from Barnhill is one of the most ubiquitous postcard images. It is a particularly charming vista with Moncrieffe Island in the foreground and Tay Street in the background. The rail service from Dundee to Perth began in 1827, but terminated at Barnhill on the east side of the river until a wooden railway bridge was opened in 1849. There were problems with the foundations of the old bridge and the replacement bridge was designed by the engineers of the Caledonian Railway and opened in 1862.

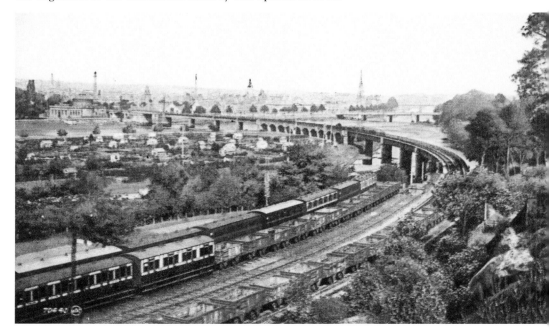

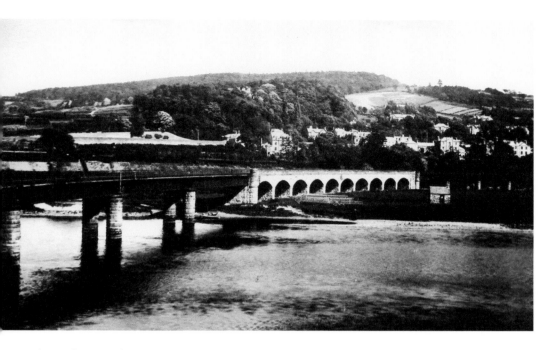

The Railway Bridge
The railway bridge is a composite structure with iron girder spans to the east of Moncrieffe Island, a central solid masonry section of ten stone arches on the island, and more girder spans to the west. It was one of the first large plate-girder bridges in Scotland. The southernmost span could originally be opened to allow shipping further upstream. A pedestrian walkway runs beside the railway track.

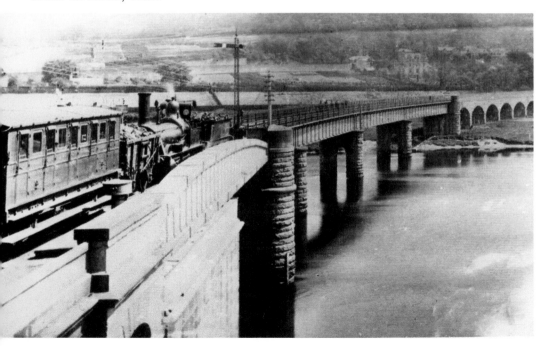

CHAPTER 4
CHURCHES

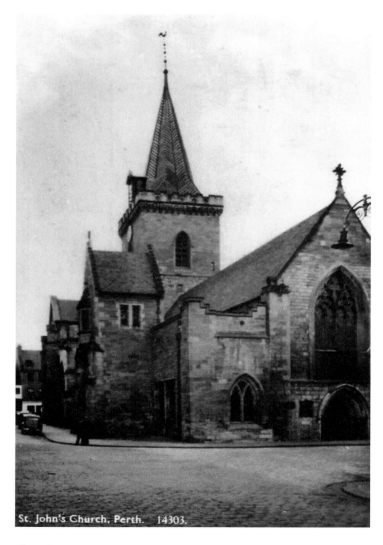

St. John's Church, Perth. 14303.

Churches

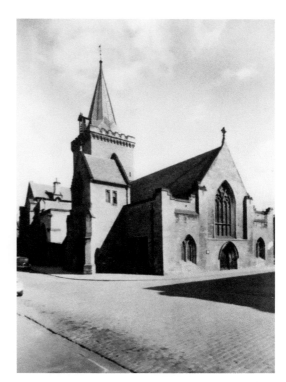

St John's Kirk, St John Street

St John's Kirk is Perth's oldest surviving building. The original church was completed by 1241, although most of the present structure dates from between 1440 and 1500. However, there are references to a well-established church dedicated to St John the Baptist in Perth as early as 1128. The church was so central to life in Perth that the town was at one time known as St Johnstoun.

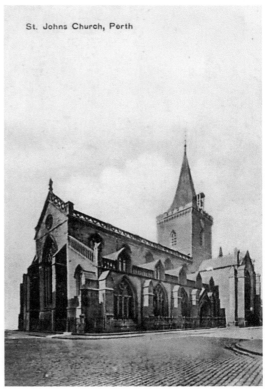

St. Johns Church, Perth

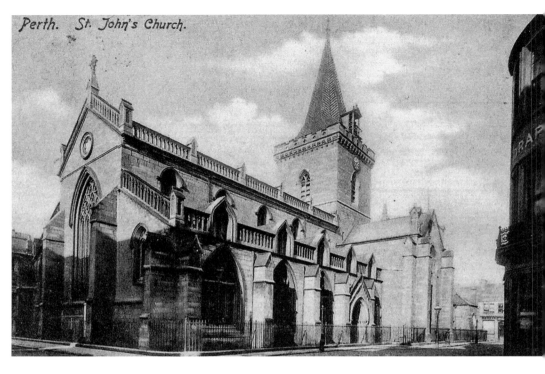

Perth. St. John's Church.

St John's Kirk, St John Street
By 1715, three different congregations were using the subdivided building and there followed a long period of neglect. In 1923, the church was extensively renovated and restored by Sir Robert Lorimer as a memorial to the people of Perth who sacrificed their lives in the First World War.

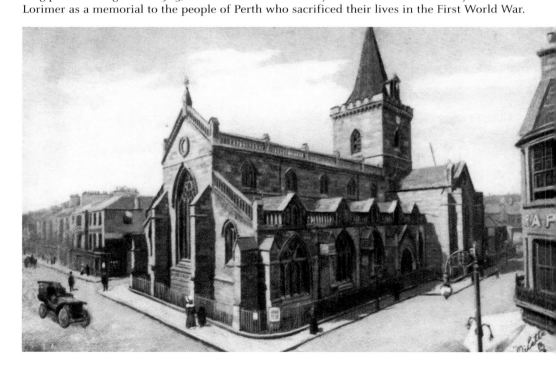

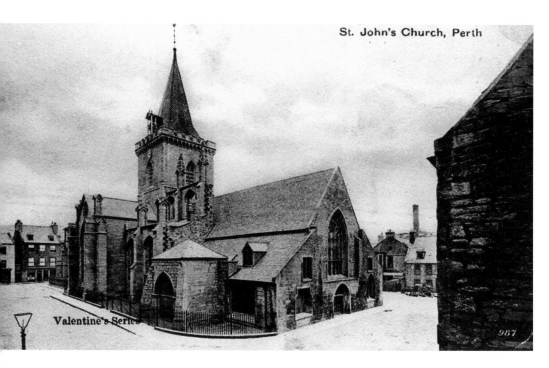

St. John's Church, Perth

Valentine's Series

St John's Kirk, St John Street

On 11 May 1559, John Knox preached a provocative sermon against idolatry at St John's, which so inflamed the congregation that they smashed the altars in the church and went on to sack the monasteries in the town. The events were the starting point of the Scottish Reformation.

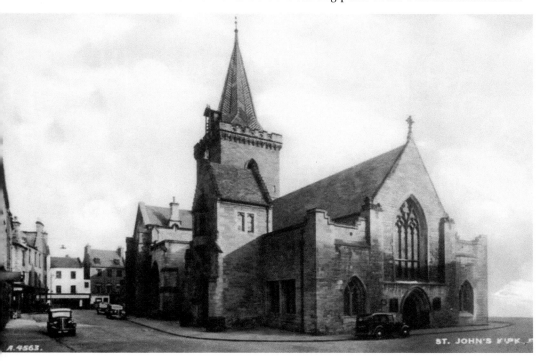

ST. JOHN'S KIRK,

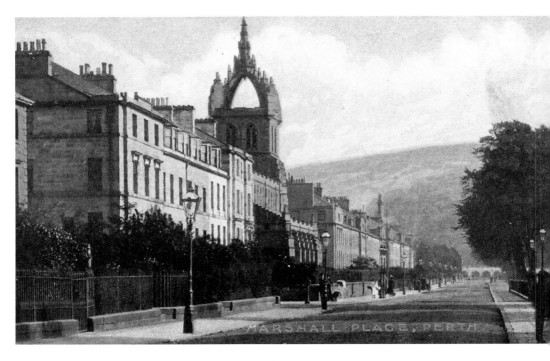

St Leonards-in-the Fields Free Church, Marshall Place

St Leonards-in-the Fields Free Church, with its distinctive crown spire, dates from 1885 and forms an impressive landmark on Marshall Place, overlooking the South Inch. It was built as St Leonard's Free Church and designed by the London-based architect John James Stevenson (1831–1908). There were some early construction difficulties as part of the city's lade lay underneath the site.

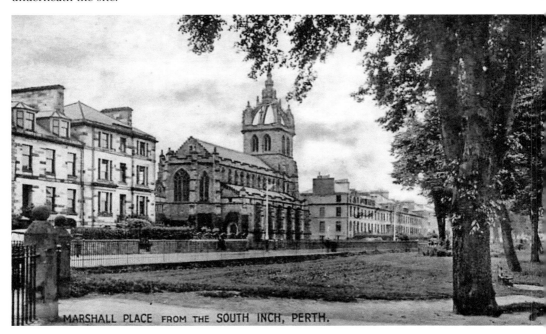

MARSHALL PLACE FROM THE SOUTH INCH, PERTH.

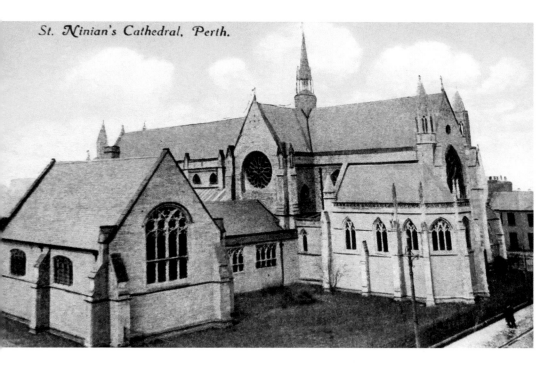

St. Ninian's Cathedral, Perth.

St Ninian's Cathedral, Atholl Street and North Methven Street

St Ninian's Cathedral occupies a prominent location on the corner of Atholl Street and North Methven Street. It was built in phases and first opened for worship in 1850. It stands on the site of an older Dominican monastery. The design was by renowned ecclesiastical architect William Butterfield (1814–1900). It was the first cathedral begun in Britain after the Reformation.

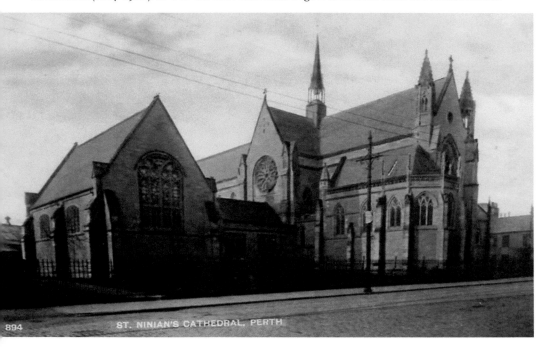

894 ST. NINIAN'S CATHEDRAL, PERTH

CHAPTER 5

THE NORTH AND SOUTH INCH

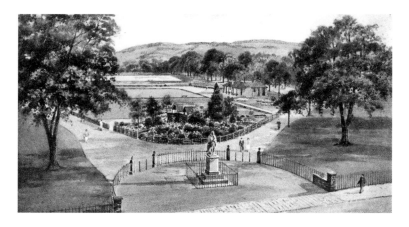

Entrance to the South Inch at Marshall Place

The South Inch and North Inch define the south and north boundaries of the city centre and, together with the River Tay, contribute to Perth's unique character. The South Inch was used as an archery ground, a bleach field, for cattle grazing, horse racing and a burial ground for plague victims. The golf course on the South Inch was popular during the eighteenth century, but was abandoned in 1833, when the Royal Perth Golfing Society moved to the North Inch.

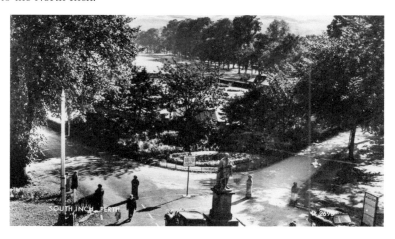

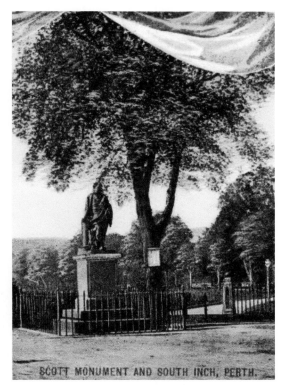

SCOTT MONUMENT AND SOUTH INCH, PERTH.

South Inch, Walter Scott Statue

The statue of Sir Walter Scott and his deerhound, Maida, at the Marshall Place entrance to the South Inch is by local sculptors the Cochrane brothers, and was first unveiled in 1845 on a site at the foot of the High Street. It was moved to its current site in 1877.

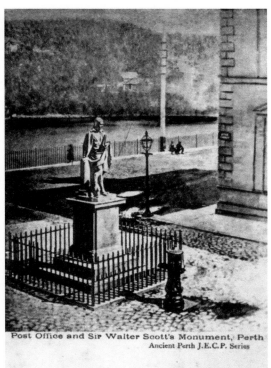

Post Office and Sir Walter Scott's Monument, Perth
Ancient Perth J.E.C.P. Series

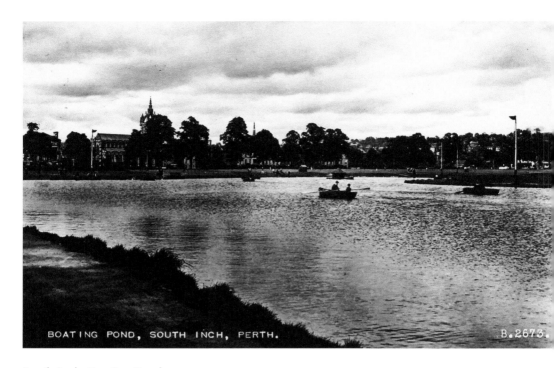

BOATING POND, SOUTH INCH, PERTH. B.2673.

South Inch, Boating Pond

In the 1840s, there were proposals to build a railway station on the South Inch, which provoked outrage among the people of Perth and resulted in a petition being submitted to Parliament against the loss of their cherished green space. The boating pond at the South Inch was recently given a makeover as part of a project to upgrade facilities at the park.

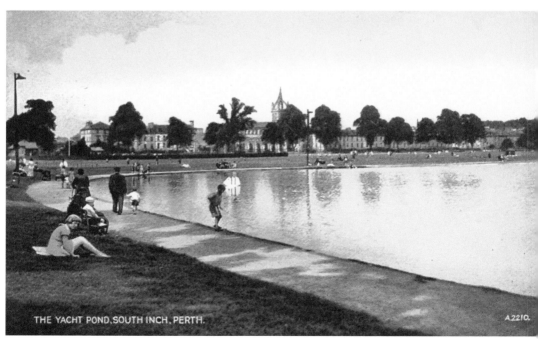

THE YACHT POND, SOUTH INCH, PERTH. A2210.

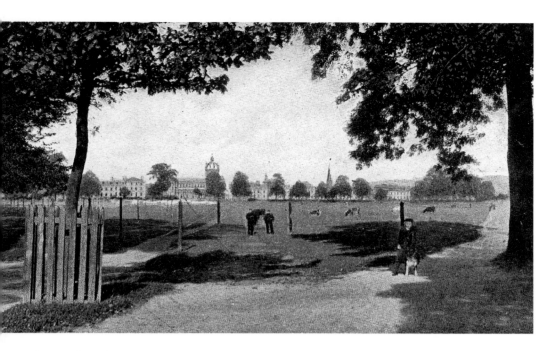

The South Inch

Perth surrendered to Oliver Cromwell's Parliamentarians in 1651 and the South Inch was the site of Cromwell's citadel, built to subdue the surrounding area and garrison the army. Cromwell's enormous citadel was on the east side of the South Inch. The north wall ran parallel to Greyfriars burial ground, and extended from the river to the site of Marshall Place. The walls of Greyfriars, 140 houses, the hospital, and the Grammar School were demolished for building materials. The citadel was dismantled after Cromwell's death, and its site is now occupied by the South Inch car park.

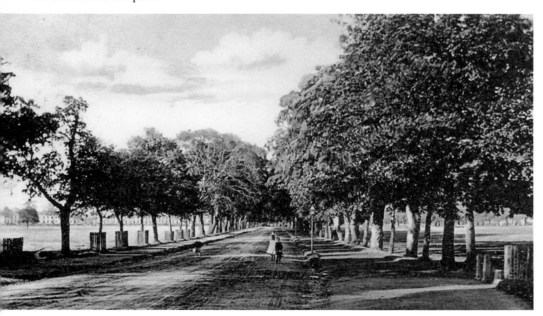

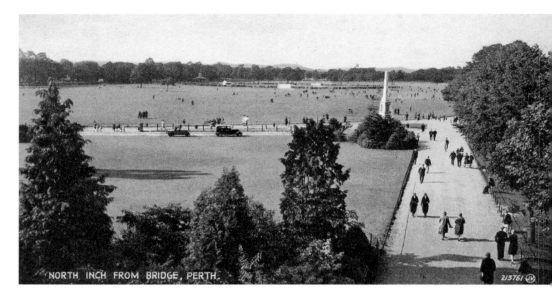

NORTH INCH FROM BRIDGE, PERTH.

North Inch

The natural beauty of Perth is greatly enhanced by these delightful recreation grounds, the North and South Inches, and there is probably no other place in Scotland where the inhabitants possess such a precious boon.

(Samuel Cowan, *Perth, the Ancient Capital of Scotland*, 1904)

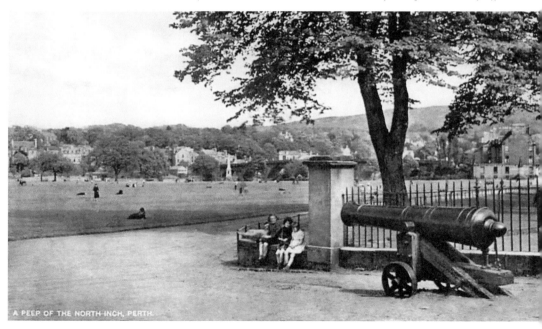

A PEEP OF THE NORTH INCH, PERTH.

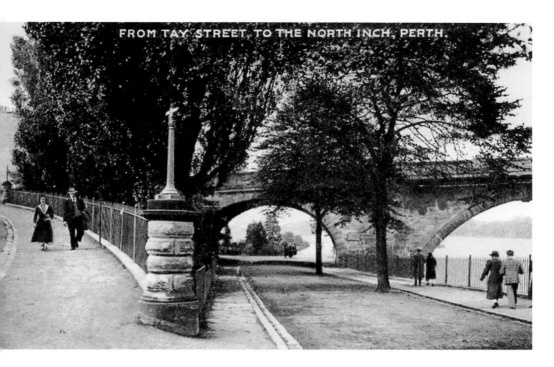

FROM TAY STREET TO THE NORTH INCH, PERTH.

North Inch

The North and South Inches were given as common ground for the use of the people of Perth by King Robert III in the 1370s. Inch means island or meadow from the Gaelic '*innis*'. The North Inch has served many functions over the centuries: grazing and cattle markets, bleaching and drying laundry, witch burning, boating, horse racing, golf, rugby and cricket.

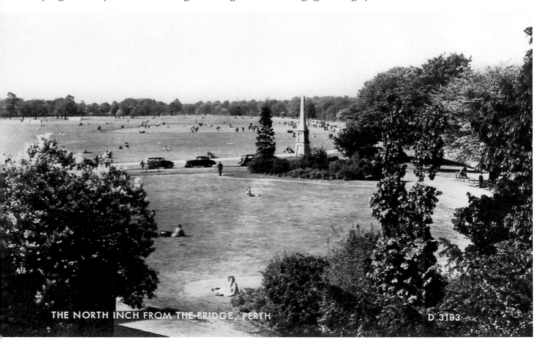

THE NORTH INCH FROM THE BRIDGE, PERTH D 3183

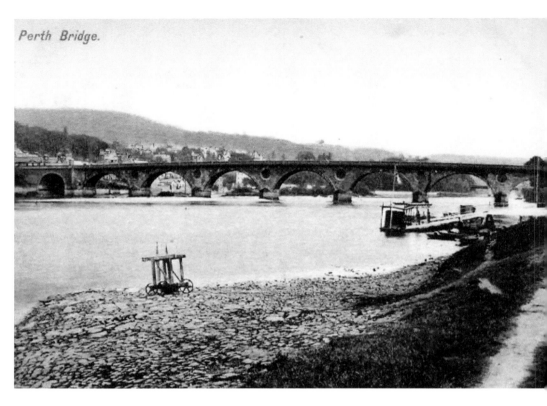

Perth Bridge.

The Boat Station, North Inch
The boating station at the North Inch was a popular spot for a paddle in the Tay, messing about in boats or relaxing, with a picnic, to take in the magnificent sweep of the Old Bridge.

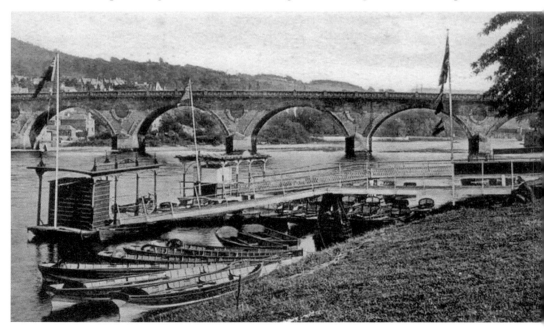

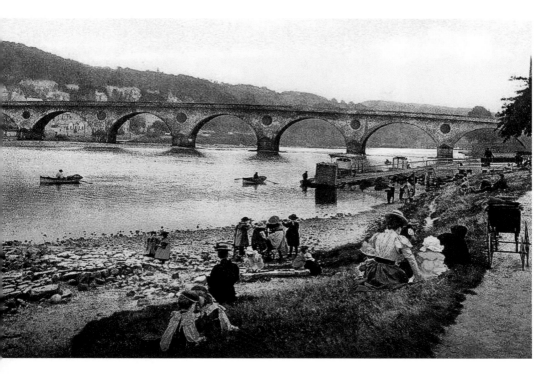

The Boat Station, North Inch
The circular openings between the spans of the bridge were originally intended to allow floodwater to flow through, but were not required and were blocked up.

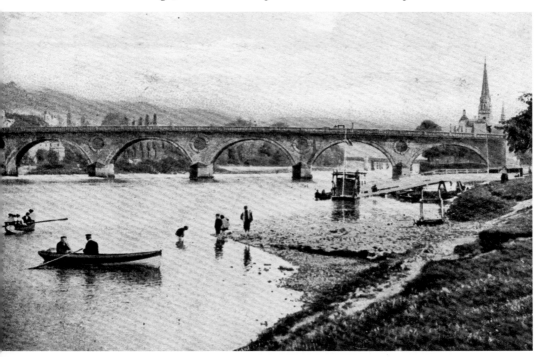

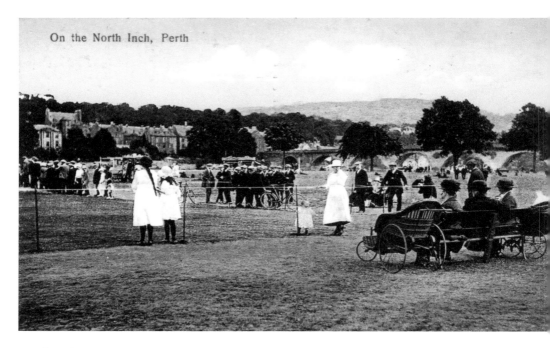
On the North Inch, Perth

North Inch Sport

The North Inch has always been a popular venue for sporting activities. A racecourse ran around the perimeter until it moved to Scone in 1908. The North Inch was an important venue for cricket – the first recorded match was in 1849. The North Inch golf course had six holes in 1803, which was increased to eighteen by Old Tom Morris in 1892. In 1861, golfers took exception to trees, which had been planted on the North Inch by the council, which interfered with their game – a mob of enraged golfers marched to the Inch and uprooted them.

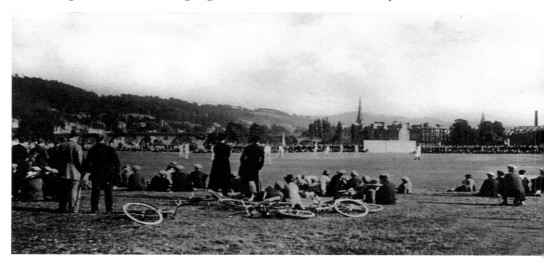

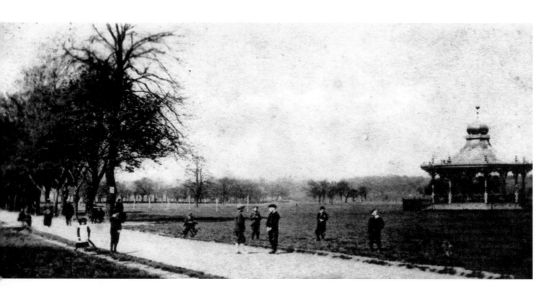

North Inch, Bandstand

The bandstand was located on the west side of the North Inch. It was gifted by James Pullar. The opening concert was a performance by the band of the 6th Royal Dragoons on 25 July 1891. The bandstand was a popular venue during the summer months, with bands providing musical entertainment. In 1959, the bandstand was declared unsafe, demolished and sold for scrap.

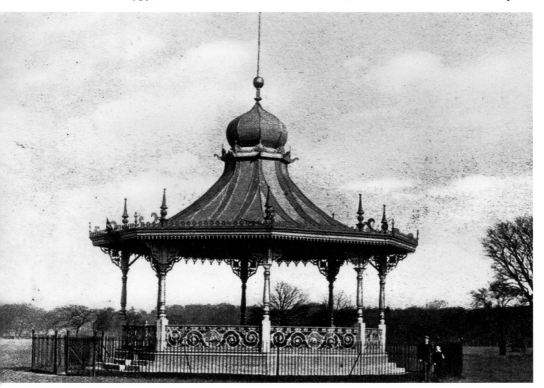

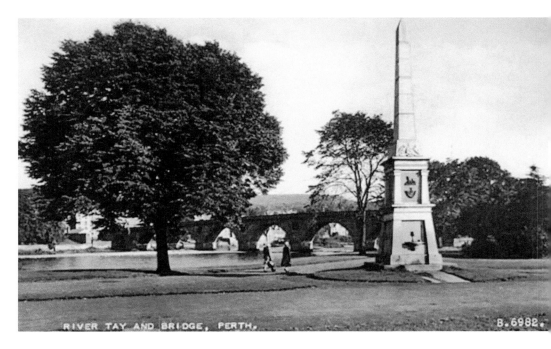

North Inch, the Lynedoch Monument

The Lynedoch Monument was unveiled in December 1896 to commemorate the raising of the 90th Light Regiment of Foot, the Perthshire Volunteers, in 1794. The inscription reads: 'Raised May 1874 by Thomas Graham of Balgowan who was promoted for his services in Italy Spain and Holland to the rank of General 1809. Made a Knight of the Bath 1812 and created Baron Lynedoch 1814.' Thomas Graham owned a number of estates around Perth. He took up military service at the age of forty-five and rose to a senior role under Wellington.

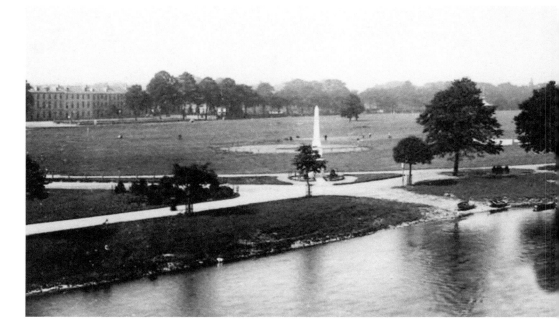

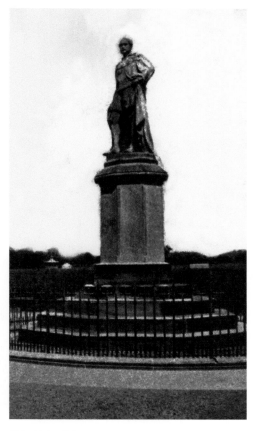

Prince Albert Memorial

The 8-foot-high statue of Prince Albert overlooks Charlotte Street at the southern end of the North Inch. Prince Albert is depicted in the robes of the Order of the Thistle and holding a plan of the Crystal Palace, which was erected in Hyde Park, London, for the Great Exhibition of 1851. The memorial was sculpted by William Brodie and was unveiled by Queen Victoria in 1864, three years after Albert's death. The statue is inscribed: 'City of Perth Memorial of His Royal Highness Prince Albert inaugurated by Her Majesty Queen Victoria, Tuesday, 30th August, 1864'.

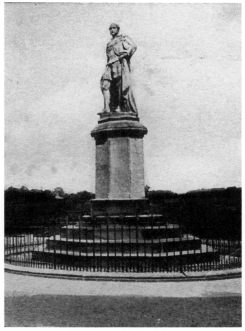

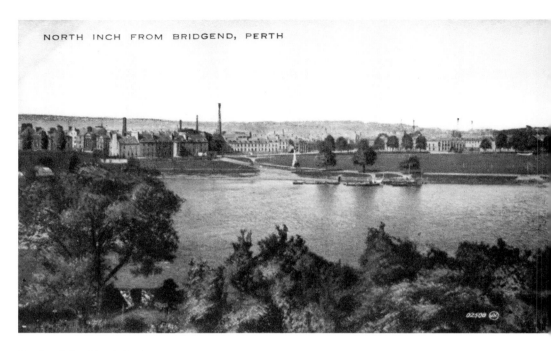

Battle of the North Inch

The Battle of the North Inch, or Battle of the Clans, was a fight to settle a feud between the Clan Chattan and Clan Kay (or Cameron, or Davidson – there are different versions of the event). It was fought in September 1396 in front of King Robert III. Thirty men were selected to represent each clan. A fierce battle commenced, the clansmen charging at each other armed with axes and swords. The result was a victory for Clan Chattan, who had eleven survivors; all but one of their opponents, who escaped by swimming over the Tay, were killed.

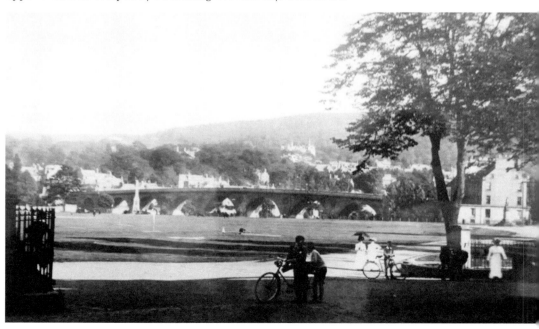

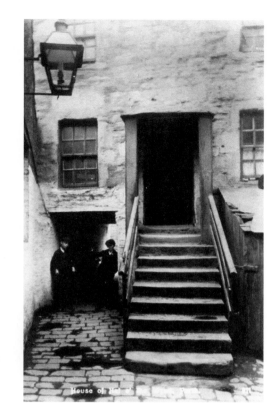

Hal o' the Wynd House

Just before the Battle of the Clans was about to begin it was discovered that Clan Chattan was a man short. A financial incentive was offered and a local blacksmith, Henry Smith, described as 'small and bandy-legged, but fierce', volunteered to stand in. Smith was one of the survivors. He was also known as Hal o' the Wynd and the character of Henry Gow in Sir Walter Scott's novel *The Fair Maid of Perth* is loosely based on Smith. An eighteenth-century house on Mill Wynd is known as Hal o' the Wynd House.

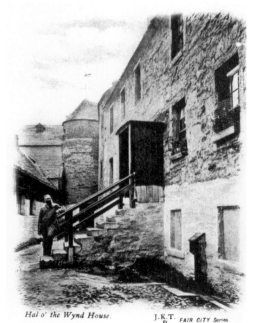

Hal o' the Wynd House. J.K.T. P. FAIR CITY Series.

CHAPTER 6

KINNOULL HILL, THE BUCKIE BRAES AND CHERRYBANK

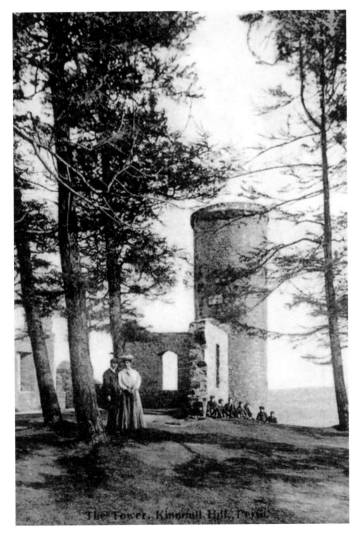

The Tower, Kinnoull Hill, Perth.

Kinnoull

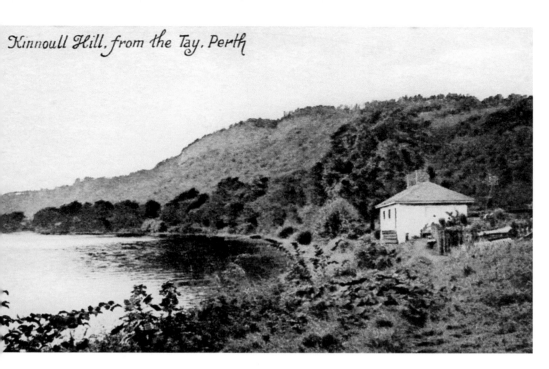

Kinnoull Hill, from the Tay, Perth

Kinnoull Hill

The stupendous ridge of rock, called the Hill of Kinnoull, rising to the height of more than six hundred feet nearly perpendicular from the river, and other heights, contributes greatly to adorn the landscape, and, being mostly planted, forms a shelter and ornament of no common description.

(J. P. Neale. *Views of the Seats of Noblemen and Gentlemen*, 1828)

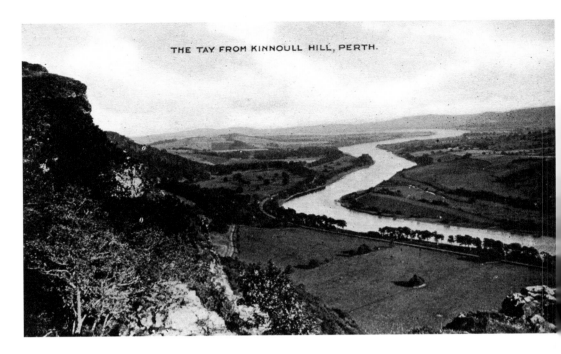

THE TAY FROM KINNOULL HILL, PERTH.

Kinnoull Hill

The walk to the top of Kinnoull Hill is rewarded by magnificent views over the River Tay and beyond from the steep south-facing summit. The name Kinnoull is derived from the Gaelic meaning the 'head of the rock'. Kinnoull Hill is the highest of the five hills that make up the Kinnoull Hill Woodland Park. The others are Corsiehill, Deuchny Hill, Barn Hill and Binn Hill. Kinnoull Hill was gifted to the city of Perth in 1924 and was officially recognised as Scotland's first woodland park in 1991.

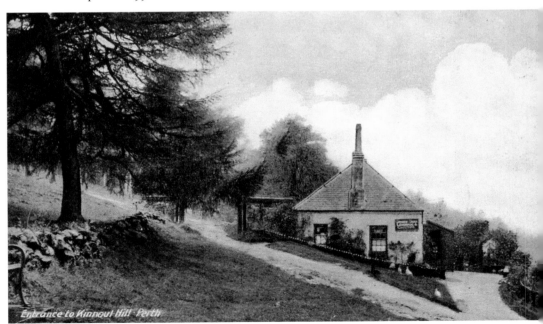

Entrance to Kinnoul Hill Perth

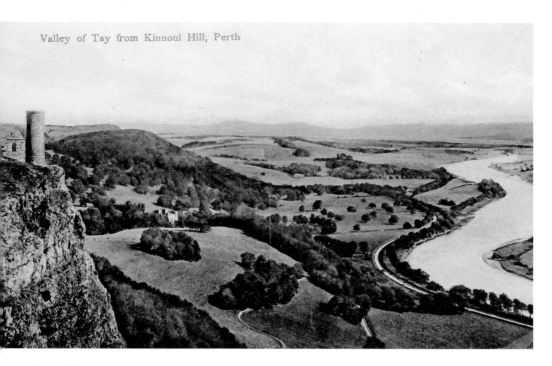

Valley of Tay from Kinnoul Hill, Perth

Kinnoull Tower

The picturesque Kinnoull Tower is a romantic folly on the edge of a dramatic rocky outcrop and forms a major local landmark. It was built by 1829 by Lord Grey of Kinfauns, who had been inspired by castles perched on hills in the Rhine Valley.

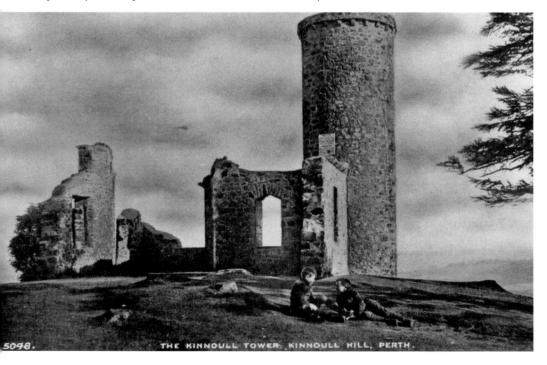

5048. THE KINNOULL TOWER. KINNOULL HILL, PERTH.

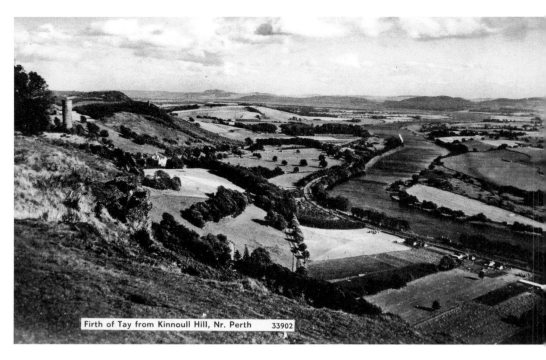

Firth of Tay from Kinnoull Hill, Nr. Perth 33902

The Binn Tower
The Binn Tower is a prominent landmark in the panoramic views of the Carse of Gowrie and the River Tay. The tower was built in 1815 by the 14th Lord Gray of Kinfauns as an observatory and dramatic eyecatcher.

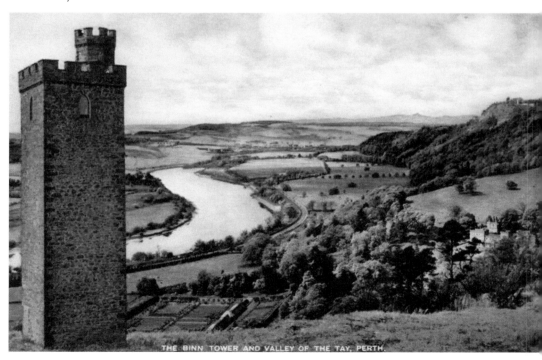

THE BINN TOWER AND VALLEY OF THE TAY, PERTH.

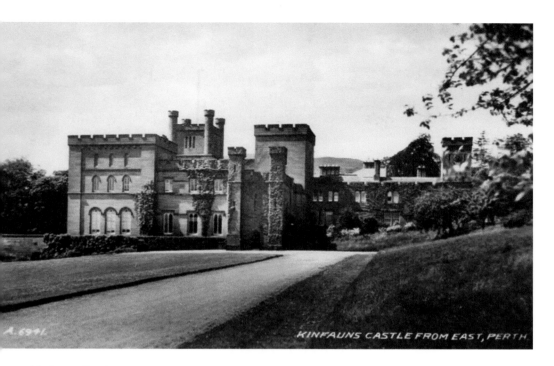

KINFAUNS CASTLE FROM EAST, PERTH.

Kinfauns Castle

Kinfauns Castle is a large castellated mansion on the edge of Kinnoull Hill. It dates from the 1820s and was designed by Sir Robert Smirke for Lord Gray on the site of an earlier medieval stone fortress. The building remained in the ownership of the Gray family until 1930. The castle was a hotel for a time and has been in private ownership since 2004.

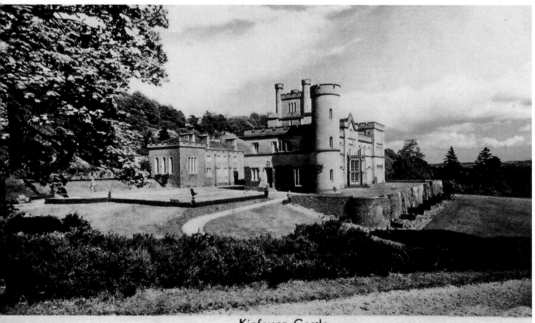

Kinfauns Castle.

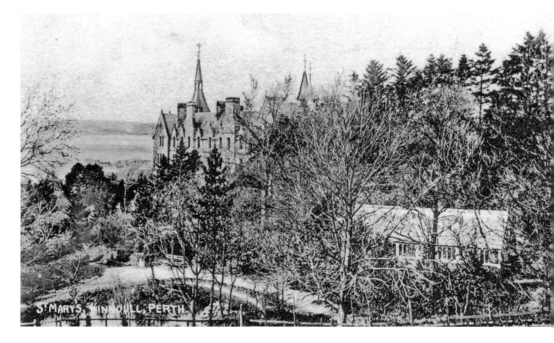

St Mary's Monastery, Hatton Road

St Mary's Monastery, on the wooded slopes of Kinnoull Hill, was built in 1868–70 as the base for the Congregation of the Most Holy Redeemer (the Redemptorist Order) in Scotland and is used as a monastic house and ecumenical religious retreat. The building was designed by local architect A. G. Heiton in a rather austere Gothic style. It was the first Roman Catholic monastery to be constructed in Scotland since the Reformation.

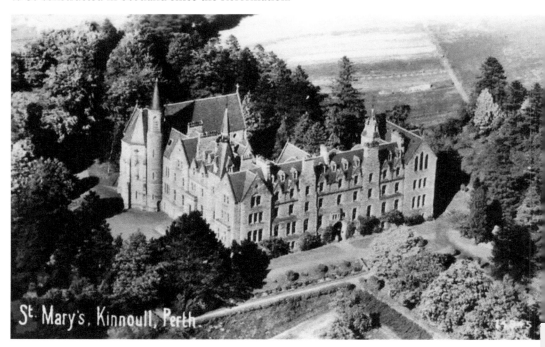

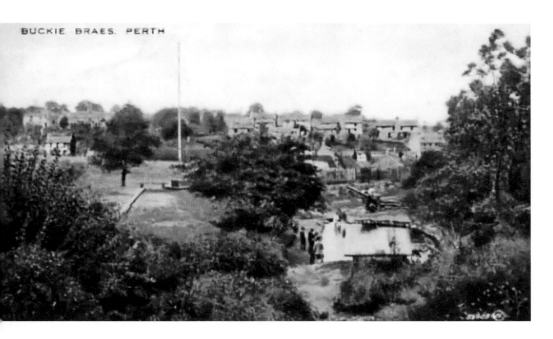
BUCKIE BRAES. PERTH

The Buckie Braes

'How sweet we spent life's early years,/Among thy fragrant, smiling briers,/Ne'er fashed wi' ony wardly fears/Among the Buckie Braes.' The Buckie Braes, 'a delightfully sequestered spot', were opened as a pleasure ground in 1911. They were a popular rendezvous for Perth youngsters and 'a favourite recreative resort' for tea parties, picnics and walking. In 1924, the Inches Committee of Perth Town Council noted the inadequacy of the amusements provided for the children at Buckie Braes and approved a new joy wheel. The gun at the Buckie Braes, which was a relic of the First World War, was removed in 1937.

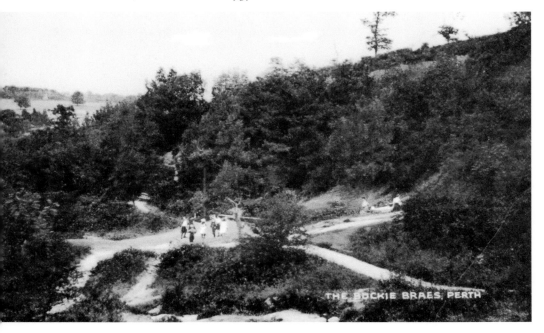
THE BUCKIE BRAES, PERTH

THE 'SEE SAW' BUCKIE BRAES, PERTH

The Buckie Braes

In May 1911, a correspondent to the *Perthshire Advertiser* noted that 'instead of the City Fathers beautiful picture of old age being refreshed and youth happily entertained by the pleasure ground at the Buckie Braes: on too many occasions they had been invaded by somewhat undesirable gangs of young men and women whose behaviour has frequently verged on hooliganism, with constables having to be detailed to see that something like decorum is maintained on the Buckie Braes.' In June 1911, at Perth Children's Court, five fourteen-year-old boys appeared before Baillie Crombie charged with causing a breach of the peace by cursing and swearing at girls on the Buckie Braes.

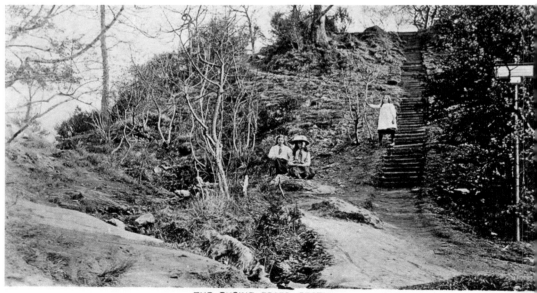

THE BUCKIE BRAES, PERTH

897

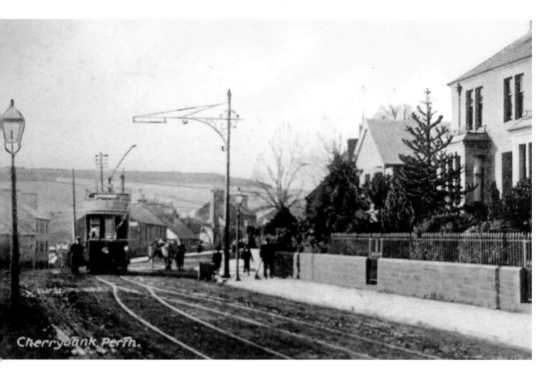

Cherrybank, Perth.

Cherrybank
Cherrybank, which was a small rural community to the west of Perth, expanded significantly with the development of the tram service.

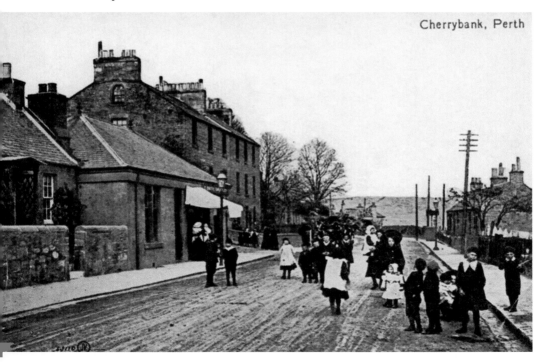

CHAPTER 7

SCONE

Old and New Scone

The old village of Scone was removed to allow the remodelling of the palace and layout of the policies in the early 1800s. In 1805, the inhabitants were moved just over a mile east of the old village to the newly constructed planned settlement of New Scone.

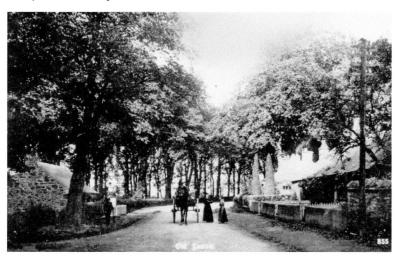

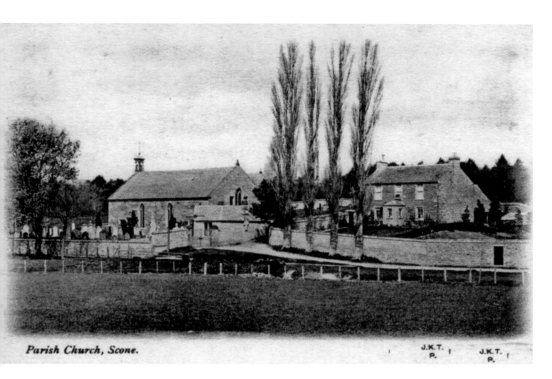

Parish Church, Scone.

Scone Old Parish Church and the Douglas Gardens

The parish church at Old Scone was built in 1784. In 1804, it was dismantled and re-erected in this present position. David Douglas (1799–1834) was born in Scone. He was a botanist and plant collector who introduced the Douglas fir into Scotland.

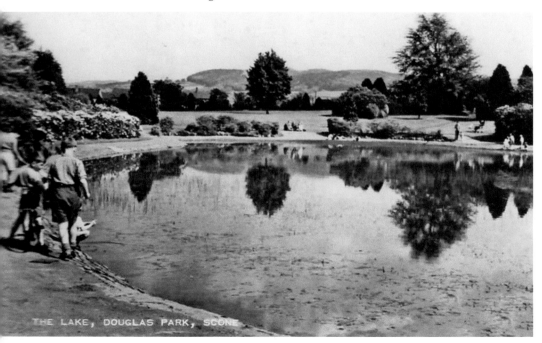

THE LAKE, DOUGLAS PARK, SCONE

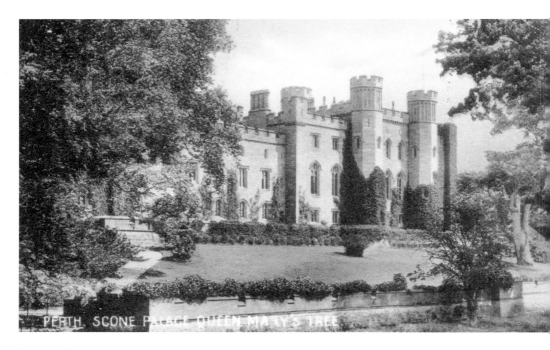

Scone Palace

Scone Palace is situated on a site with ancient historical connections. The Augustinian priory and Bishop's Palace, founded by Alexander I in 1120, were destroyed by a mob in 1559, following John Knox's rabble-rousing sermon at St John's Kirk. A new house was built by the Gowrie family in 1580. However, following the events of the Gowrie Conspiracy, King James VI gifted the house to Sir David Murray as a reward for his loyalty.

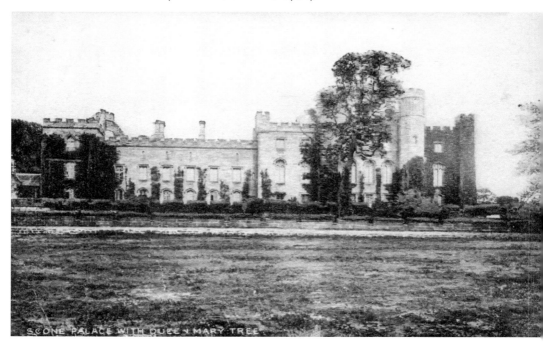

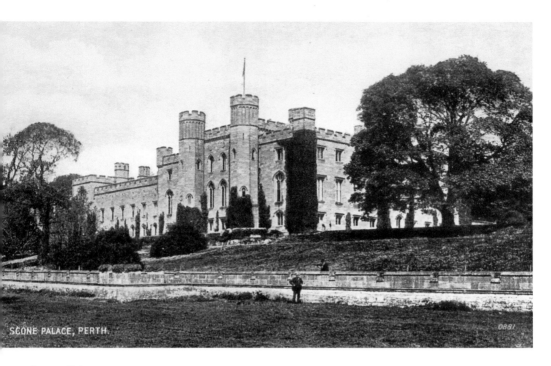

Scone Palace

Scone Palace was remodelled in the early 1800s as a castellated mansion in the Gothic style with a profusion of picturesque battlemented towers and parapets by William Atkinson for William, 3rd Earl of Mansfield. The core of the building is the sixteenth-century house.

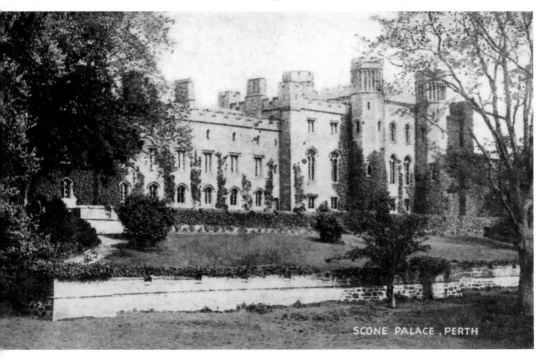

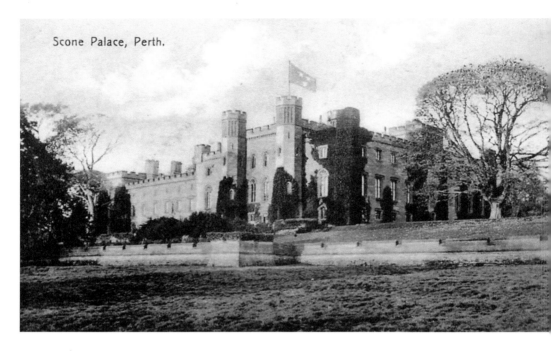

Scone Palace, Perth.

Scone Palace

Moot Hill in the grounds of Scone Palace was the ancient site of the coronation of Scottish kings. A replica of the Stone of Destiny, which was the emblem of sovereignty for Scottish monarchs, stands on the hill. There are numerous legends that surround the stone. It was brought to Scone by Kenneth MacAlpin in AD 843, confiscated and integrated into the throne at Westminster Abbey at the end of the thirteenth century. Stolen by nationalists in 1950, it was recovered and returned to Westminster Abbey and moved to Edinburgh Castle in 1996.

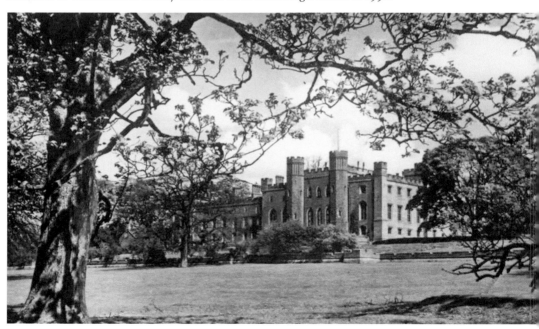

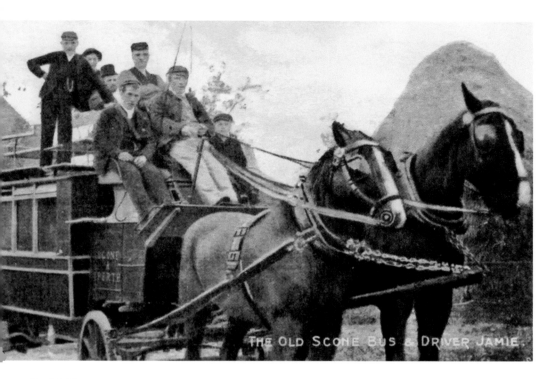

Perth's Trams

A horse-drawn tram service started on 17 September 1895 with a line from Perth to Scone. Scone was the terminus and main depot for Perth's trams.

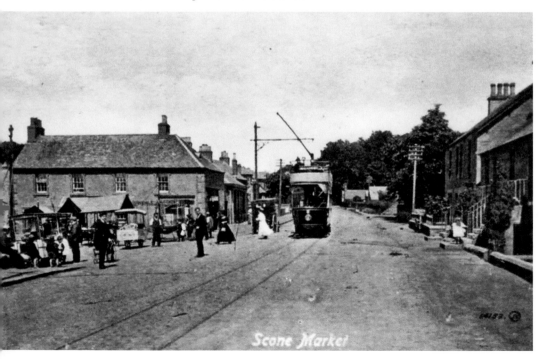

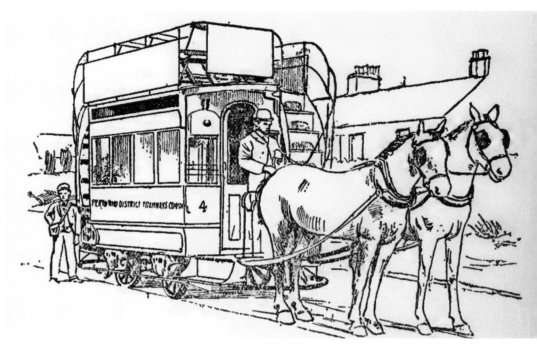

Perth's Trams

In October 1903, the horse tramways were taken over by Perth Corporation Tramways. The card commemorating the last running of the horse-drawn trams reads: 'In Affectionate Remembrance of the Perth Horse Cars', 'They did their work their day is done' and 'Ring out the old Ring in the new'.

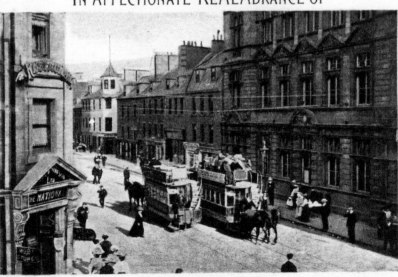

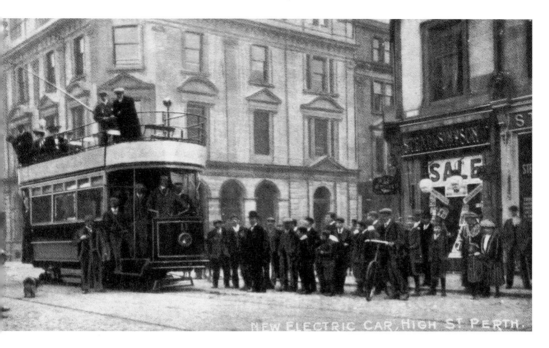

NEW ELECTRIC CAR, HIGH ST PERTH.

Perth's Trams

Perth's electric tram service opened on 31 October 1905. There was a festival atmosphere on the day, with eager crowds turning out for a first view of the new vehicles. The trams ran on a single track with loops to allow the trams to pass. The main route was from Scone to Cherrybank with branches to Craigie and Dunkeld Road. The maximum speed permitted was 12 mph, but a rather racy 16 mph was allowed on the straight run between Perth and Scone. The Perth trams closed on 19 January 1929 and were replaced by bus services.

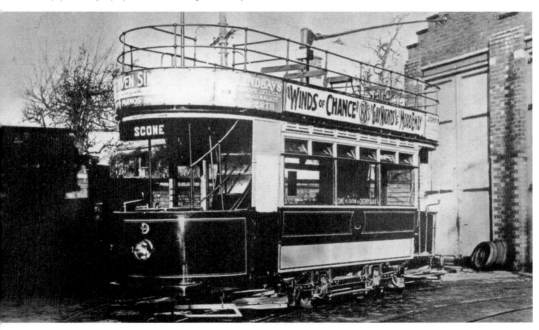

CHAPTER 8

EVENTS

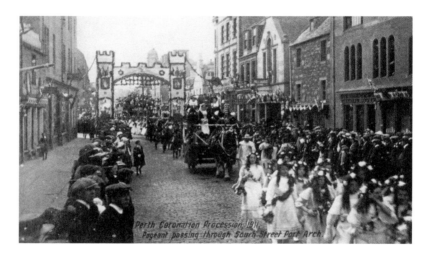

Perth Coronation Procession, 1911.
Pageant passing through South Street Port Arch.

Coronation, 1911

The celebrations in Perth for the Coronation of George V on 22 June 1911 were carried out on an extensive scale. The afternoon pageant was 'representative of the British Empire, and proved a magnificent display'. There were a dozen cars, each emblematic of different parts of the Empire. They marched through the principal streets to the North Inch.

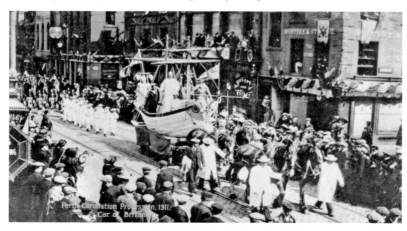

Perth Coronation Procession, 1911.
Car of Britain.

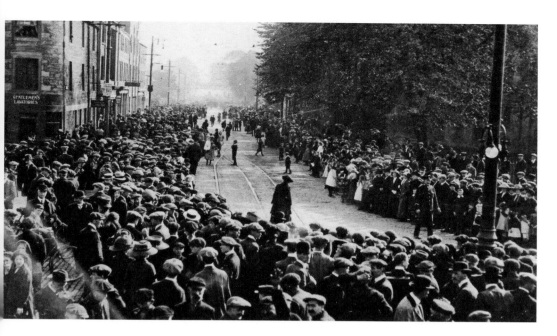

Royal Visit, 1914

On 10 July 1914, King George V and Queen Mary were given a 'rousing welcome' when they visited Perth to open the new Royal Infirmary. The royal progress through Perth was disturbed by suffragettes. One woman, Rhoda Fleming, jumped on the footboard of the royal car. It was noted that the royal couple seemed a little agitated due to the suffragette attack. A number of suffragettes were being held in Perth prison at the time and it was the focus of intense protest with 'Suffragettes perambulating the precincts of the prison, where their sisters are confined and harassing the prison officials by their attention.'

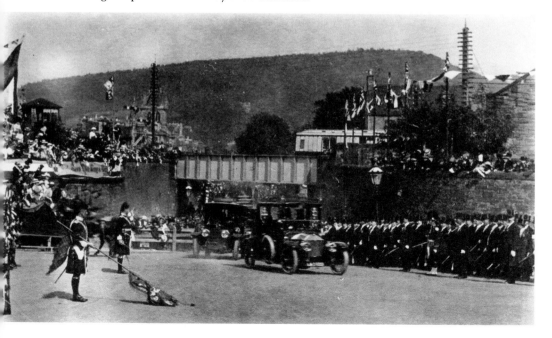

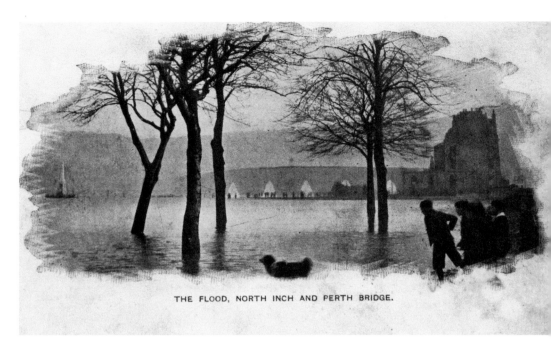

THE FLOOD, NORTH INCH AND PERTH BRIDGE.

Perth Floods

The fast-flowing waters of the Tay have been the source of a number of extreme floods throughout the history of Perth. The first recorded flood was in 1210 and drowned many, including the king's son. In 1621, Perth Bridge was destroyed and the highest flood level ever recorded was in 1814. The image of a flooded Marshall Place is from August 1910. Flood defence works including embankments, walls, flood gates and pumping stations, completed in 2001 at a cost £25 million, now protect the city.

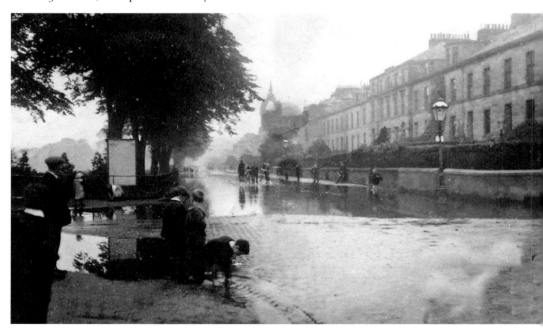